SpringerBriefs in Geography

SpringerBriefs in Geography presents concise summaries of cutting-edge research and practical applications across the fields of physical, environmental and human geography. It publishes compact refereed monographs under the editorial supervision of an international advisory board with the aim to publish 8 to 12 weeks after acceptance. Volumes are compact, 50 to 125 pages, with a clear focus. The series covers a range of content from professional to academic such as: timely reports of state-of-the art analytical techniques, bridges between new research results, snapshots of hot and/or emerging topics, elaborated thesis, literature reviews, and in-depth case studies.

The scope of the series spans the entire field of geography, with a view to significantly advance research. The character of the series is international and multidisciplinary and will include research areas such as: GIS/cartography, remote sensing, geographical education, geospatial analysis, techniques and modelling, landscape/regional and urban planning, economic geography, housing and the built environment, and quantitative geography. Volumes in this series may analyze past, present and/or future trends, as well as their determinants and consequences. Both solicited and unsolicited manuscripts are considered for publication in this series.

SpringerBriefs in Geography will be of interest to a wide range of individuals with interests in physical, environmental and human geography as well as for researchers from allied disciplines.

More information about this series at https://link.springer.com/bookseries/10050

Daniela A. Ottmann

Ecological Building Materials for Deserts and Drylands

Daniela A. Ottmann
Faculty of Society and Design, School
of Architecture, Centre for Comparative
Construction Research
Bond University
Gold Coast, QLD, Australia

ISSN 2211-4165 ISSN 2211-4173 (electronic)
SpringerBriefs in Geography
ISBN 978-3-030-95455-0 ISBN 978-3-030-95456-7 (eBook)
https://doi.org/10.1007/978-3-030-95456-7

This Springer imprint is published by the registered company Springer Nature Switzerland AG
The registered company address is: Gewerbestrasse 11, 6330 Cham, Switzerland

Foreword

We open the cover to this book in a climate and biodiversity emergency. Communities and nations finally seem to be reaching an accord on the solid science advising that Herculean action is needed to take us, by 2030, much of the way to a future with net-zero CO_{2e} emissions. It's an urgent existential imperative if we're to avoid runaway collapse of those earth systems that have nurtured us for eons past.

We're advised by the World Green Building Council that our industry is responsible for 40% of global anthropogenic emissions. This is a gobsmacking figure of which, depending on regional climate and socio-economic setting, around half can be attributed to emissions embodied in building materials, in their harvest from earth's resources, through processing/manufacture, to assembly in constructed outcomes. The manufacture of Portland cement, steel and fired clay bricks alone account for the lion's share of these embodied emissions.

We often hear that timber harvested from the world's tall natural forests makes for a natural building material that has anthropogenic emissions tied to its procurement fully offset by atmospheric emissions sequestered as carbon in the wood. But this is a flawed argument that disregards the hugely greater carbon store and subsequent sequestration potential lost to natural forests, when harvested in the ways they mostly are, to procure vast volumes of wood product, mostly for the developed world.

Above and elsewhere, we don't even begin to consider also diversity and abundance in our natural biosphere, so gravely impacted by the consumptive ways of the wealthier of our species.

Meanwhile, deserts and drylands are inhabited by three billion people. These land areas are expanding and becoming drier still with climate change. This is a great cause of concern for the world's entire population.

In such a troubling context, this book looks to the earth's natural abiotic (mineral) and biotic (organic) resources, as available in deserts and drylands, for the revival of vernacular architecture as well as for innovation with new composite materials and construction systems.

The emphasis of this investigation is towards building materials that are without the devastating earth systems impact, social injustice and opacity attached to now globally dominant supply chains. The focus is on low cost, locally accessible and

ecologically sensitive material cultures suited not only to architecture for desert and dryland communities but also more broadly for this fragile and finite planet.

I wholeheartedly endorse the work of the author Daniela A. Ottmann and am honoured to recommend this book to the reader.

On Boonwurrung Country, South Paul Haar Architect
Gippsland, VIC, Australia
November 2021

Acknowledgements

This work, initiated in 2011, was carried out at the GUtech/RWTH Aachen in Oman, AUDRC/UWA and Bond University in Australia.

My thanks go to the previous Australian Urban Design Research Director Prof. Dr. Joerg Baumeister for his encouragement for this research and writing of this monograph. The development of the "eComposite Combinator" tool builds on research over the last decade conducted on passive climate design and vernacular material systems on the Arabian Peninsula and Australia and makes the integration of new information on circular cities, the Agenda 2030 and UN SDGs.

The field work in Oman was only possible through my research students and their families, namely: Alisraa Al Saadi, Amr Al Zadjali, Asia Al Lamki, Asila Al Busaidi, Ayesha Rahman, Fatma Al Rahbi, Fouz Al Busaidi, Haitham Al Rawahi, Hamida Al Riyami, Hanan Al Riyami, Iman Al Ajmi, Khadija Al Mandhari, Mahir Al Arafati, Maiysa Al Mandhari, Maryam Al Taei, Mohammed Al Madhani, Nadeen Tall, Nasser Al Sayegh, Nibras Al Molahi, Noor Al Raisi, Ricky Vinayachandra, Rola Al Harthy, Sabreen Al Badai, Sabrina Ahmed, Saleh Al Adawy, Shadha Al Mazrouai, Shaima Al Raisi, Sultan Al Zadjali, Talal Al Haremi, Taleed Rose.

I would also like to thank Prof. Heinz Gaube, Marja Dorr, Salah Al Mazrui, Lara Pinho and Fernanda Parnenzini for their support.

Also thanks to the continued research on ecological materials experimenting and testing: Drs. Nima Talebian and Zia Javanbakht.

The opinions expressed herein are those of the author and should not be construed as reflecting the views of the Universities listed.

Gold Coast on Kombumerri Country, Daniela A. Ottmann
Australia
October 2021

Summary

In light of climate change, desertification and urbanisation, this book intends to shed light on possible climate-adaptive building materials for desert and dryland environments. Topics covered include Climate Culture, Climate Design and Climate Matters. Their interactions help future cities and architecture in climatically challenged hot desert places develop climate-adaptive design techniques and appropriate material systems.

Particular emphasis lies on ecological composites for advances in sustainable construction and building materials for deserts and drylands. Ecological materials for an adequate climate design of healthy houses are investigated. Key principles also include holistic design concepts that respond to the potential materials and their bioclimatic advantages.

This approach is destined to lead to a renewed design morphology inspired by the vernacular and driven by contemporary complexities around climate change and circularity.

This publication can be viewed as three components interwoven into a handbook of climate in drylands, the culture of building and materials systems in deserts and the quest for sustainable development. A combinatory matrix for eco-composite materials reveals future research recipes and inspires the reader for further climate matters investigations. The author is convinced that the 'seed' of sustainable materiality and her systems evolves out of the concept of integrated ecosystems that feed into a low-emission urban and building metabolism. Socio-cultural and bioclimatic inclusive design decisions based on ecological materials will serve multifunctional benefits for the inhabitant's comfort and well-being.

Contents

Chapter 1
Building, Climate, Matters: Are We Creating the Right Future?

Abstract The ongoing debate over observed climate change and urbanisation has centred around three critical questions: (Climate Zones) how can greenhouse gas emissions associated with urbanisation and construction in deserts and drylands be reduced in the future, (Climate design) which geographical locations will be most impacted by ongoing desertification rates, and (material, resources, and comfort) to what extent will climate-adaptive design and adequate material systems change have an effect on future. Yet, for an adequate climate design of healthy houses, especially in hot arid climate zones, there is a universe to discover alternatives to the 'new' old-fashioned (and undisputed climate change enhancers) plastic, concrete, and steel. The purpose of this publication is to synthesise existing knowledge about resources and ecological material systems with an emphasis to expand on future ecological hybrid materials for desert and dryland architecture.

Keywords Climate change · Materials · Buildings · Drylands · Climate design

1.1 Background and Importance of the Research

While writing, the 26th COP (UN Climate Change Conference) is being prepared to discuss greenhouse gas emission pathways of all countries on this planet with a renewed appeal to boosting the global response to climate change, sustainable development, and poverty eradication efforts.

Reduced energy demand, decarbonized power supply, and addressing embodied carbon stored in building materials are all urgently needed to decarbonize the building and construction sector. Global warming, unprecedented urbanisation rates, and increasing desertification cause people to suffer from urban heat stress and noise and high concentrations of contaminants in the air, water, and soil.

In the context of extreme hot and arid climates, the vision for this publication originated in a study on decaying knowledge of traditional building knowledge in Oman's rich historical oasis settlements. Here beyond urban and architectural knowledge also material systems were collected and analysed (Ottmann 2012). The astounding results and richness of the vernacular compared to the contemporary construction industry and products used (predominately steel, concrete and higher

© The Author(s), under exclusive license to Springer Nature Switzerland AG 2022 1
D. A. Ottmann, *Ecological Building Materials for Deserts and Drylands*,
SpringerBriefs in Geography, https://doi.org/10.1007/978-3-030-95456-7_1

energy-consuming air conditioning systems to combat indoor climate comfort with outdoor climate conditions of a desert) were further extended into the Australian drylands and deserts. The initially used building materials of the vernacular buildings were ecological before oil-boom induced mechanical devices responsible for indoor climate control (AC's) were introduced. The globalised progress of the 'wonder composite' materials around steel-reinforced concrete and Ordinary Portland Cement[1] have added to the dementia of traditional material and building knowledge. Here alternatives to massive GHG contributing materials have existed over millennia. The energetic running cost of climatised interiors in challenging climate regions like deserts was low due to 'smart' design and construction decisions. Those have manifested in cultural innateness of matter to become a material, form of nature to become the shape of dwellings, and water and air to shape entire settlements.

1.2 Gap in Knowledge

Beyond resources' limits to growth, and in the discussion of enclosed circular city economies, materials as the smallest unit of cyclables in the built environment comprises an important aspect to the Agenda 2030s net-zero buildings discussion (UN 2016). As the choice of non-renewable and high embodied energy building materials are heavily disputed, alternative natural materials find a renaissance. The fashionable architecture world now sympathises with rammed earth walls, straw bale houses, bamboo structures, Structural Insulation Panels and Cross-laminated-timber (CLT). Yet, for an adequate climate design of healthy houses, especially in underrepresented climate zones such as deserts and drylands, there is a universe to discover alternatives to 'new' old-fashioned (and undisputed climate change enhancers) plastic, concrete, and steel, eco-logic material systems.

1.3 Aim of the Book

This book aims to bring together some knowledge on resources and materials systems in focusing on future ecological resources for desert and dryland architecture. Existing literature and material specifications compile a comprehensive collection of materials, is organised into categories that structure materials to distinct properties to generate new compounds. Through the eco-composite combinator at the end of the publication, the model can be applied to a pick'n'mix discovery of material systems beyond the collection of potential composite matrix and composite aggregate materials for and in deserts and drylands.

[1] The production of 1 tonne of Portland cement generates 0.95 T of carbon dioxide (Davidovits 2013).

This initial collection of ecological materials covers the characterisation of biotic and abiotic resources for materials in hindsight to eventually map those as aggregates and binder for potential new combination of composite materials, just like the historic wisdom of ancient dryland dwellers like the Sumerians have applied local materials into cultural development of their built environment. The brief material specifications reveal benefits for suitable bioclimatic design and construction thereof for advances in sustainable construction and building materials for deserts and drylands.

1.4 Distinctive Features of the Book

The logic of an eco-approach to design and test new possible composite materials here for deserts and dryland is the goal of this publication. Further investigations of how the design holistically responds to the potential materials and their bioclimatic advantages in combination with production and assembly technologies, might lead into a renewed design morphology driven by ever more complex parameters. This publication features aspects around:

- 'New' old-fashioned alternatives to plastic, concrete and steel.
- Factoring in adequate building materials in deserts and drylands.
- Overview handbook for designers, architects, engineers and planners.
- Local resources have driven building materials in hindsight of traditional uses.
- Inspiration to further investigations for new materials.
- Speculates into the future and comes up with future research recipes.
- Combines material science with building construction, architecture, climate-appropriate design and adds well-being factors for indoor health.

1.5 Overview of Chapters

As a whole, this publication can be thought of as three components that are inter-twined to form a guidebook on the exploration of (future) ecological composite materials in and for deserts and drylands. Figure 1.1 provides an overview of how the various chapters are interrelated.

The first foundational Chapters (2–5) give an overview of the climatic context in deserts and drylands, desert climate culture, climate design in drylands, and materials systems in deserts considering sustainable urban development.

The second part (Chaps. 6–8) is an overview of so far sourced ecological materials that are clustered in biotic, abiotic and hybrid building materials.

The final part (Chaps. 9–11) draws on the findings of the materials collected and reorganises them into applicable composite phases. A final combinatory matrix in Chap. 10 reveals potentials for new ecological building materials and provides 'recipes' for future research recipes into sustainable Climate Matters investigations

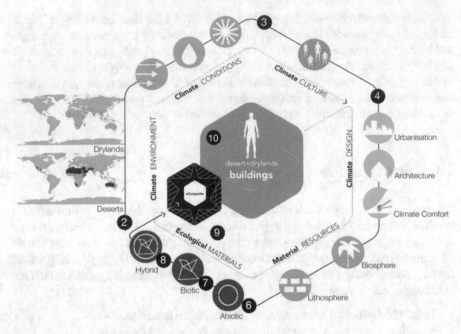

Fig. 1.1 Climate zones, culture, climate design and materials interrelations (numbers indicate the allocated chapters)

We wish the readers inspiring insights and delightful ideas for materials that feed into a low emission, healthful circular metabolism for true net-zero built environments in drylands. Expanding the study of building materials as cultural artefacts within a specific socio-cultural and bioclimatic environment could lead to new ideas for adaptive climate designs that go beyond purely aesthetic considerations.

References

Davidovits J (2013) Geopolymer cement. A review Geopolymer Institute, technical papers, vol 21, pp 1–11

Ottmann DA (2012) Traditional building knowledge Oman. https://storymaps.arcgis.com/stories/4cbb6650aa6342758941ec785f04b40d. Accessed 3 Nov 2021

UN (2016) Transforming our world: The 2030 agenda for sustainable development. https://sdgs.un.org/sites/default/files/publications/21252030%20Agenda%20for%20Sustainable%20Development%20web.pdf.sustainabledevelopment.un.org

Chapter 2
Rapid Urbanisation, Desertification and SDGs: Limits to Sustainability

Abstract Efforts to limit the global warming potential increase to 1.5 °C require adaption strategies such as reduced energy and water usage in urban areas through greening cities and water recycling. Yet, desertification vulnerable areas continue to expand in tandem with an ongoing population expansion in precisely those climatically challenged regions. This chapter is devoted to summarising the policy and context of desertification, drylands, and the growing population of drylands. Within the constraints of natural resources required to fuel the rising urban construction demand, Urban Mitigation Strategies encompassing SDG15 to combat desertification are explored in conjunction with SDG11 (Sustainable Cities and Communities) in hindsight of ecological material systems drylands.

Keywords Global urbanisation · Desertification · Resources · Materials · Sustainable development goals

2.1 Desertification and Climate Change

During the 1992 Rio Earth Summit, the major challenges to sustainable development were identified as desertification, climate change, and biodiversity loss. Desertification is defined by the United Nations Convention to Combat Desertification (UNCCD) as 'land deterioration in arid, semi-arid, and dry sub-humid regions caused by a variety of factors, including climatic fluctuations and human activities'. While climate change can drive desertification, the process of desertification can also alter the local climate through change of atmospheric CO_2 levels and its related global climate change, or they can alter the surface energy and water budgets, directly impacting the local climate (Mirzabaev et al. 2019).

The United Nations Convention on Climate Change (UNCCD) was established in 1994 as the only legally enforceable international agreement integrating environment and development with sustainable land management. The Convention focuses on the arid, semi-arid, and dry sub-humid areas known as the drylands, which are home to some of the world's most vulnerable ecosystems and peoples (UNCCD 2012).

© The Author(s), under exclusive license to Springer Nature Switzerland AG 2022
D. A. Ottmann, *Ecological Building Materials for Deserts and Drylands*,
SpringerBriefs in Geography, https://doi.org/10.1007/978-3-030-95456-7_2

Table 2.1 Table of aridity index and global land area distribution based on Mirzabaev et al. (2019)

Classification	Aridity index	Global land area (%)
Hyper-arid	AI < 0.05	7.5
Arid	0.05 < AI < 0.20	12.1
Semi-arid	0.20 < AI < 0.50	17.7
Dry subhumid	0.50 < AI < 0.65	9.9
	Total world	47.2

In the recent IPCC special report on desertification, 'there is high confidence that climate change will exacerbate the vulnerability of dryland populations to desertification, and that the combination of pressures coming from climate change and desertification will diminish opportunities for reducing poverty, enhancing food and nutritional security, empowering women, reducing disease burden, and improving access to water and sanitation' (Mirzabaev et al. 2019).

Despite widespread recognition of the importance of desert and drylands development in today's globe, there have been very few books published on the correlation of increasing urbanisation and its toll on the planet to date. Climate change impacts on soil, agriculture, vegetation, water resources, and other environmental and physical aspects of desert development are covered in the collective volumes published on this topic. Yet buildings are a top emitter of climate-changing gases into our atmosphere: 37% of energy-related CO_2 emissions in 2020 (Global Alliance for Buildings and Construction 2021).

According to UNCCD (2011), the world's drylands occupy 47.2% of the global land area (Table 2.1) and house nearly one-third of the world's population. Further facts on deserts and drylands are:

- The majority of the world's dryland population lives in developing countries; drylands store 46% of the planet's carbon; and drylands account for 44% of all cultivated land.
- Plants that are endemic to the drylands account for 30% of all plants grown today.
- Australia, China, Russia, the United States, and Kazakhstan have the most dryland areas.
- Drylands cover at least 99% of the surface area of six countries (Botswana, Burkina Faso, Iraq, Kazakhstan, Moldova, and Turkmenistan).

At the heart of the world's hyper-arid drylands below an aridity index of 0.03[1] are five major zones of natural deserts (mainly in hyper-arid zones):

[1] The Aridity Index (AI) is a numerical indicator of aridity based on long-term climatic water on long-term climatic water deficits and is calculated as the ratio P (Precipitation)/PET (Potential evapotranspiration) (Cherlet et al. 2018).

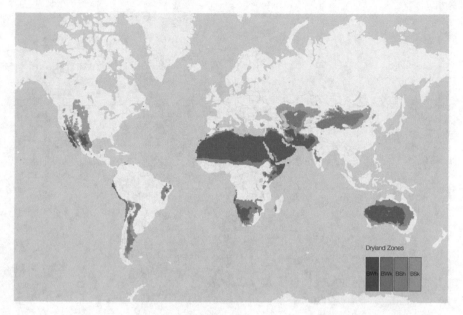

Fig. 2.1 Desert and drylands climates 2001–2025[2]

- the Afro-Asian Desert (a great belt stretching from the Atlantic Ocean to China, including the Sahara, Arabian, Iranian, Touranian, Thar, Takla Makan, and Gobi deserts),
- the North American Desert (comprising the Great Basin, Mojave, Sonoran, and Chihuahuan deserts),
- the Atacama and Patagonian Deserts in South America,
- the Namib and Kalahari Deserts in south western Africa, and
- the Great Sandy, Great Victoria, and Simpson Deserts in Australia (Grainger 1990).

Increasingly, desert boundaries are expanding beyond the classification of the lowest biodiversity in arid resource-scarce places (Figs. 2.1 and 2.2). Hence the quest to combat desertification includes activities that are part of the integrated approach to develop arid areas under aspects of:

(i) prevention and/or reduction of land degradation;
(ii) rehabilitation of partly degraded land; and
(iii) reclamation of desertified land (UNCCD 2012).

Beyond the UNCCD also the UN Sustainable Development Goal SDG 15.3 states that 'By 2030, combat desertification, restore degraded land and soil, including land affected by desertification, drought and floods, and strive to achieve a land

[2] Map based on: Basemap (Esri 2021) and Dryland zones after Koeppen-Geiger climate classification: B (arid) (Kottek et al. 2006).

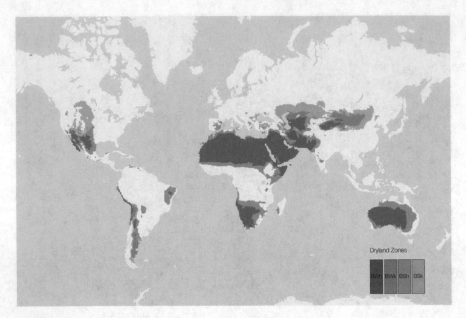

Fig. 2.2 Desert and drylands climates increase 2076–2100[3]

degradation-neutral world.' The UN (2021) describes deserts as one of Agenda 21s 'fragile ecosystems,' and has dedicated Chapter 12 is to 'fighting desertification and drought.' since it impacts one-sixth of the global population, seventy percent of all drylands, and one-quarter of the world's total geographical area. Solutions to the cross-sectoral aspects of decision-making for the sustainable use and development of natural resources, including soils, minerals, water, and biota, are the focus of Chapter 10 of Agenda 21, which deals with integrated planning and management of land resources.

Expanding human needs and urban development activities (see Fig. 2.3) is putting increasing strains on land resources, causing competition and conflict and resulting in inefficient resource usage. It is feasible to reduce conflicts, establish the most effective trade-offs, and link social and economic development with environmental protection and enhancement by considering all uses of land in an integrated manner, thus assisting in the achievement of sustainable development objectives.

[3] See Footnote 2.

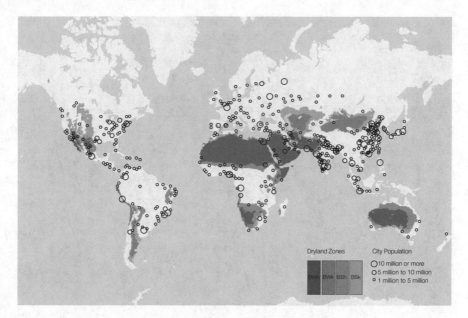

Fig. 2.3 Deserts and dryland urbanisation by city population 2018[4]

2.2 Deserts, Drylands and Urbanization

Combatting desertification is not just an issue in the so called arid regions. As depicted in Fig. 2.4 desertification vulnerability expands and affects vast regions already urbanised or with an urbanisation increase. Thus, the demographic prospects of arid territory are at stake, as are urbanisation requirements and accompanying GHG emissions from the construction industry.

The IPCC (Bazaz et al. 2018) determined that urban areas are particularly sensitive to climate change, with a high level of confidence. There are also plenty of difficulties related to rising aridity causing serious concerns among urban populations, infrastructure, businesses, and ecosystems. Heat stress, severe storms, excessive precipitation (and subsequent flooding and landslides), increasing air pollution as temperatures rise, drought, and water scarcity are only a few of them.

But those challenging impacts of climate change describe the scenarios for existing cities. However, increasing urbanisation trends foster the expansion of existing and production of new cities in drylands. With that comes the cost of the environmental budget with associated greenhouse gas emissions that might even accelerate further desertification prone climate change scenarios. Reciprocal trends are urban stressors based on climate change and other anthropogenic impacts on the well-being of urban

[4] Map based on: Basemap (Esri 2021), Dryland zones after Koeppen-Geiger climate classification: B (arid) (Kottek et al. 2006), and (UN 2018).

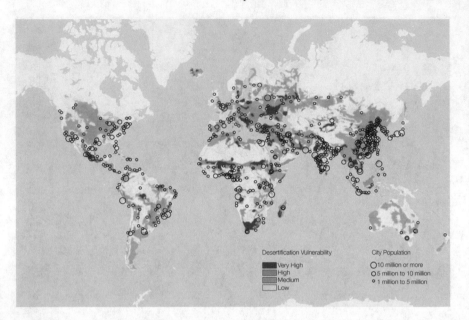

Fig. 2.4 Desertification vulnerability and dryland urbanisation increase by 2030[5]

dwellers such as transportation and production noise, heat stress, glare/UV effect, albedo effect, air pollution.

Extreme heat events will become more common as the climate warms, leading to greater heat stress, particularly in metropolitan areas. Already existing effects in cities are heat island effects as an example of positive reinforcing feedback loops resulting in weather related mortality rates in urban environments. It is well understood that humans have a specific upper limit for coping with heat and humidity stress and that prolonged exposure to high temperatures and humidity levels above this limit will result in hyperthermia and mortality. As the global mean temperature rises, this physiological barrier is expected to become more critical in the future.

To examine this physiological limit on the Arabian Peninsula under future scenarios of rising aridity, a study combined an increasing index (4 °C this century) of temperature and humidity (which represents humans' physiological threshold) and current carbon emissions. According to that research, if present emissions continue unabated, extreme heat waves will become routine in cities like Abu Dhabi, Dubai, and Doha by 2070. Today's hottest days could become a near-daily occurrence. Beyond the Arabian Peninsula, rising hotspots do not augur well for the future human habitability of cities unless significant mitigation is implemented. According to the IPCC, urban adaptation is necessary to handle the various issues that an urbanising planet faces since urban areas as one of four critical global systems that can accelerate and upscale climate action. Efforts to limit the global warming potential increase to

[5] Map based on: Basemap (Esri 2021), Desertification Vulnerability (Rubel and Kottek 2010) and City Population (UNEP and ISRIC 2018).

1.5 °C require adaption strategies such as reduced energy and water usage in urban areas through greening cities and water recycling. Emissions from the global building stock in place in 2050 will need to be 80–90% lower than the present day. A 30% reduction in final energy use by the transport sector in conjunction with a renewables supply of 70–85% are recommended (Bazaz et al. 2018).

The materials required for mobility, housing, construction, and food all establish connections and interconnections between cities and industry. Here an interchange of heat, waste, materials, or water, an industrial-urban symbiosis typically occurs.

Increased rates of material recycling, as well as the substitution of high-carbon-intensity products such as ecological building materials with renewable-material-based products, could help accelerate urban transformations.

2.3 Global Warming Urban Mitigation Strategies

Other options for mitigating climate change include desert greening, ecological engineering, and oasification (using hydrology/dense woody plant cover to rehabilitate a slope's hydrological, edaphic, and botanical deterioration). In the world of architecture and construction, bioclimatic design and the use of ecological materials have the potential to intricately close an urban metabolism while also integrating all of the needs of an urban system. Here, traditional climate-engineered oasis towns demonstrate that they have established habitable space and location for humans by constructing and maintaining their own micro-ecosystem within a wider context on inhabitable, low-vegetation, and high-arid levels of a desert (e.g. in Fig. 4.1). As a result, oasis settlement might be referred to as a mitigation strategy for desert climate change through proper Design for Climate in Deserts (see more in Chap. 4).

Climate change prompts us to think about the intricate relationship between architecture, cities, climate, and society once more, and in greater depth.

We have big, big problems flooding, earthquake, and many foolish things which now people are doing - I mean, these self-made catastrophes. We are able to give to every man on the street the possibility to help himself. And to fight for this was one of my duties.—Frei Otto

References

Bazaz A, Bertoldi P, Buckeridge M, Cartwright A, de Coninck H, Engelbrecht F, Jacob D, Hourcade J-C, Klaus I, de Kleijne K (2018) Summary for urban policymakers: what the IPCC special report on global warming of 1.5 °C means for cities

Cherlet M, Hutchinson C, Reynolds J, Hill J, Sommer S, Von Maltitz G (2018) World atlas of desertification: rethinking land degradation and sustainable land management. Publications Office of the European Union. https://doi.org/10.2760/06292

Esri (2021) Light gray canvas map

Global Alliance for Buildings and Construction IEA, United Nations Environment Programme (2021) Global status report for buildings and construction: towards a zero-emission, efficient

and resilient buildings and construction sector. https://webstore.iea.org/download/direct/2930?fil
 ename=2019_global_status_report_for_buildings_and_construction.pdf
Grainger A (1990) The threatening desert: controlling desertification London. Earthscan Publica-
 tions Ltd., in Associaton with UNEP, Nairobi
Kottek M, Grieser J, Beck C, Rudolf B, Rubel F (2006) World map of the Köppen-Geiger climate
 classification updated
Mirzabaev A, Wu J, Evans J, Garcia-Oliva F, Hussein I, Iqbal M, Kimutai J, Knowles T, Meza F,
 Nedjroaoui D (2019) Desertification
Rubel F, Kottek M (2010) Observed and projected climate shifts 1901–2100 depicted by world
 maps of the Köppen-Geiger climate classification. Meteorologische Zeitschrift 19(2):135
UN (2018) United Nations Department of Economic and Social Affairs. Map: percentage urban
 and urban agglomerations by size class 2018
UN (2021) Desertification, land degradation and drought. Sustainable Development Knowl-
 edge Platform. https://sustainabledevelopment.un.org/topics/desertificationlanddegradationand
 drought. Accessed 08 Oct 2021
UNCCD (2012) The convention: part 1. UNCCD. https://web.archive.org/web/20160622115952/
 http://www.unccd.int/en/about-the-convention/Pages/About-the-Convention.aspx
UNCCD ZEN (2011) Desertification. Bresson, France
UNEP, ISRIC (2018) World atlas of desertification

Chapter 3
Desert Climate Culture

Abstract The cradle of human civilizations have its home in desert and dryland regions. Cultural achievements and civilizational ingenuity go hand in hand with modifying local resources earth, vegetation, sun, wind and water. The metamorphosis of the abundant matters into entire empires and manifold inventions leads to these peoples' success. Still, it impacts the way settlements and the use of materials and passive climate design works. With no electric-mechanical apparati to make things more convenient and architectural shape had to have bioclimatic and socio-cultural integrated reasoning. Here the interdependence of the molecular composition of matters into fractals of bricks, blocks, neighbourhood clusters and entire step pyramids are interrelated.

Keywords Climate · Resources · Materials · Culture · Empires

3.1 Cradle of Civilization in Drylands

Climate, derived from the Greek *klima*, 'place, zone,' can be applied to diverse socio-cultural and bioclimatic zones, indicating the many circumstances to design and build for, against, or in conjunction with.

The bioclimatic system of the desert is a precise ecological model that forms itself in specific climatic conditions, with its own rules, biological activity, and an overall balance that the people of the Oases understand and appreciate. The desert formed as a result of natural cycles that followed the geological evolution of our planet's history and preserved a relatively stable biodiverse ecosystem. Desertification, a major human responsibility, is a sudden change to which the planet's physical and biological systems cannot adapt in time. The resulting degeneration is complete, with no hope of recreating a life cycle with new laws. The desert itself can desertify, because even a landscape of such remarkable strength—seemingly immovable—is a frail habitat, just like any other ecosystem. As a result, any human behaviour that is unable to establish its limits will have long-term and destructive consequences.

The cultural affinity for a building culture with earth, wood, or stone, as well as the perceived societal comfort level of the built environment, may be influenced by the historical context of a specific location and its socio-cultural achievements.

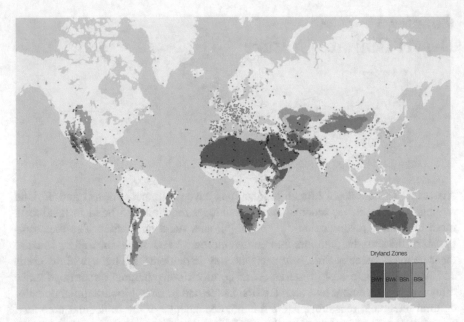

Fig. 3.1 World heritage sites in deserts and drylands 2025[1]

Various agricultural and industrial revolutions, as well as the benefits of commerce and globalization, have elevated this local adaptation to a worldwide endeavour. Amiri and Bausman (2018) describe the internationalization of the ever-expanding construction sector as global perspective, which also includes unified building technologies and specific resource utilization blended into a certain 'globalized' construction style.

The (cultural) diversity in climate-responsive vernacular architectural examples around the world has been compromised into mono-specific approaches, which has a negative impact on not only a mono-cultivated use of resources but also on the diversity of craft and skills that have emerged over millennia in various parts of the world.

Deserts and drylands, which are climatically demanding environments, are not surprisingly the cradle of civilization (World Heritage in Desert and Drylands Fig. 3.1) and the birthplace of climate architecture. Engineered habitats made of locally accessible materials, like those built by ancient Sumer at Ur, Uruk, and Eridu, have created miracles of cultural progress.

The earth, loam, and fibres in sun-backed adobes from the Euphrates and Tigris were used to build Ziggurats, which were long-lasting and sturdy buildings (ancient Mesopotamian step pyramids). These buildings, which are clad in glazed tiles and have bitumen coated plinths, provide protection from solar exposure as well as

[1] Map based on Basemap (Esri 2021), Drylands (Rubel and Kottek 2010) and Heritage Sites (UNESCO and Centre 2021).

extreme flooding events. In rural locations, simple farmsteads and intrinsically woven majlises or simpler family residences were and still are made of reed, as opposed to the denser courtyard type with roof-top terraces found in urban areas (Dethier 2020). Already, we see the fusion of abiotic and biotic components into materials that have shaped the Mesopotamian Culture and have been shaped reciprocally by it.

On vases, woven décor illustrates how clothing may have been woven, as well as full wattle buildings inspired by fish traps and even roof structures inspired by upside-down hulls of Mesopotamian reet boats. Much later the famous architect Gottfried Semper (2004) depicts in his 'Der Stil' the etymological connection of Indo-Germanic words 'Bekleidung' or 'Decke' to weaving or clothing-in habitable space to the inside and the outside.

3.2 Cultural Climate and Mitigation Strategies

Material culture is the expression of culture through material products, such as the creation of things, artefacts, relics, and so on. It comprises structures, ships, tools, and other things that serve as physical proof of (typically past) societies. It also takes into account unmodified natural elements (such as stone and ecofacts), human-created artefacts (such as pottery and glass), and human remains (skeletal material). More crucially, material culture not only exists in a context but also contributes to the formation of that context. It is more than simply a backdrop; it serves as a stage and props for human action (McGuire 1992). In current findings, the oldest statues of human civilisation, the 'Ain Ghazal Statues' (Fig. 3.2) in Jordan, incorporate such an advanced material culture. They are made from artificial lime plaster (see more in Chap. 6) as innovative artefact material.

The United Nations Convention to Combat Desertification's recent quest for 'Combatting desertification, land degradation, and drought for poverty reduction and sustainable development' (Lala-Pritchard 2015) through contributions of science, technology, traditional knowledge, and practice is not a new phenomenon; it has roots in ancient civilisations.

Mitigating the growing tendencies of desertification caused by climate change could benefit from millennia-old knowledge of deserts and drylands (see Fig. 3.2 world heritage sites). Through the clever, meticulous, and sustainable construction of agriculture, hydrology, and constructed environments, cultural achievements transformed climatically challenging areas in drylands into habitable ecosystems. The underpinning of such integrated development is a thriving material culture based on climate conditions. James Fleming and Vladimir Jankovic describe the connection between climate and culture as 'The political meanings of climate and its social implications are due to the fact that the concept itself refers to a hybrid realm comprising land, water, air, living beings, people, and cultural institutions. Klima, in this sense, is paradigmatic in its binding of culture and nature that represents civilization as a result of materiality, contingency, and particularity of place' (Roesler 2017).

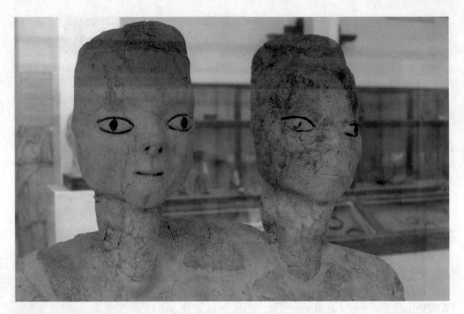

Fig. 3.2 Ain Ghazal Statues are the earliest of human civilisation 8000–6000 BCE (lime plaster)

Examples of ancient climate design strategies for a comfortable and productive built environment in deserts and drylands can be found across the cultures:

- Regional irrigation systems: *Qanat* (Iraq, Iran 1000 BCE) or *Karez* (along the Silk Road): Water Irrigation systems; also *falaj* in Oman, *surangan* in India, *khettara* in Morocco, *foggara* in Algeria, *guettara* and *m'louka* in Tunisia, *madjirat, cimbras, minas* and *zanias* in Spain, *cunicoli, ingruttati* and *bottini* in Italy, *mambo* in Japan (Laureano 2012). Puquios (Nasca, 500 CE) as tunnel irrigation system with horizontal wells;
- Urban and neighbourhood systems: *Malqaf* (Egypt), *Qanat* and *Yakhchal* system, Stepwells (India 250 BCE);
- Architecture passive design and ventilation: *Malqaf* (Egypt, since 1300 BCE); Also other wind catcher designs: *Badger* (Iran); *Barjeel* (Qatar, UAE, Bahrain); *Mungh* (Pakistan) (Ali and Kurtay 2021);
- Architecture typologies: Courtyard Typology since Neolithic times (all cultures from Morocco to China) in hot arid dryland zones to maintain a private court for air, light, ventilation and microclimate. Roman atrium around an *impluvium* (Egypt 2000 BCE) similar to the concept of *TianJing* (Chinese courtyard typology Ming dynasty 1368 + CE) around the centre pool (USC 2020);
- Material Systems: part of the *Malqaf* (terracotta vases filled with water for evaporative cooling); *Olla* (terracotta vessels) to irrigate plants in soil or used as evaporative cooling vases in openings; *Termazcal* brick vault or wooden pole dome structure (Mexican); *Chultun* (Mayan 900 BCE) underground water basin plastered with waterproof cement stucco (material made of limestone, sand, and

Fig. 3.3 Inside an Umm a Nar tower tomb 2500–2000 BCE (local limestone)

water); *TianJing* roof tile terracotta system feeding water reservoirs on structure of wooden columns and beams (USC 2020). *Sarooj* (Iran, Oman) preindustrial waterproof lime plaster and mortar since irrigation systems; similar to Qadad (Yemen) or *Tadelakt* (Morocco).

Passive design strategies like windtowers have the ability to improve the thermal performance of the interior climate for 30–35% (Ali and Kurtay 2021): so from 45 °C outdoor temperature to 29 °C indoor's through choosing the right orientation, dimension of spaces, massing ratio of space, material system (earth and light weight fibre screening).

These intricate synergies encourage to find more no-energy, low emissions and yet comfortable solutions for desert and drylands designs through often localized material systems that support the thermal performance optimizing shapes (e.g. a cone shaped tower of local limestone in Oman in Fig. 3.3).

3.3 Climate Skin and People

Beyond the natural climate, society's culturally generated climate, particularly that of the built environment, can be viewed as a support system that helps to mitigate the effects of environmental circumstances (bioclimatic and socio-cultural). Now, this support system for ensuring the well-being and comfort of its inhabitants

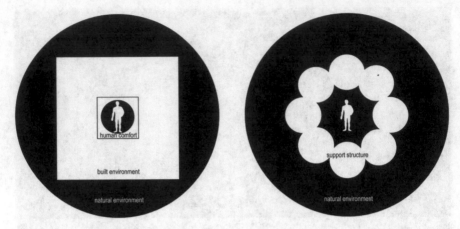

Fig. 3.4 Built environment as compensation structure and separator of natural and human environment (left) and built environment as support system interlinking natural and human environment (right) (Ottmann 2016)

can be designed, produced, and maintained using resource-intensive and energy-intensive strategies, as we have increasingly done since the industrial revolution, or we can seek to implement interconnected strategies between the human socio-cultural environment and the natural environment's conditions. This system allows for reciprocity between the needs of artificially created environments and natural conditions (climate, resources, energy, information); it works on the balance of resource utilization through innovations that enable sensitive, low-impact, adaptive, cyclical, and re-generational built environments for the well-being of its inhabitants (see built environment as support system in Fig. 3.4).

The Comfort Standard: The New Normal Climate Globally

The socio-cultural dimension of knowledge-driven innovations is frequently interpreted as technological advancements (digitalization, automation, and artificial intelligence) to ameliorate environmental preconditions and promote settlement comfort and well-being. In the case of engineering the 'perfect' indoor climate a global standard (based on mathematical formulas applicable to all climate zones) is currently applied adding to massive energy consumption and GHG emission especially in hot arid and humid climate zones. Roesler (2017) describes this global interior comfort standard from transforming from an artificial climate to a new 'natural' phenomenon. Microclimates have both tangible and intangible components: they are tangible because physical objects such as buildings, parks, heating systems, and thermal infrastructures are involved in their generation, and they are intangible because people and groups—their behaviour, institutions, and political intentions—are involved. However interior comfort levels are still engineered to a standard level (established) and used globally within the exact hygro-thermal definition disregarding a place's distinct socio-cultural and bioclimatic traditions.

Such a globalized architecture and urbanization approach is driven by frequently imported knowledge, which is especially noticeable in oil-boom impacted economies (often in deserts and drylands) that suddenly rely on imported technologies, building materials, and skill sets that emerged in possibly foreign climate culture.

As a consequence of this ongoing 'construction colonization', regional knowledge traditions and millennia-old wisdom of local material and building systems are in the process of getting lost. As such, the following chapter will look at traditional oasis villages and vernacular passive cooling architecture as spectacular examples of human co-evolution with the natural environment.

References

Ali AAA, Kurtay C (2021) Performance of the catcher in hot dry regions, Khartoum-Sudan. Gazi Univ J Sci Part B Art Hum Des Plann 9(1):29–41

Amiri A, Bausman D (2018) The internationalization of construction industry—a global perspective. Int J Eng Sci Invention (IJESI) 7(8):59–68

Dethier J (2020) The art of earth architecture: past, present, future. Thames and Hudson

Esri (2021) Light gray canvas map

Lala-Pritchard T (2015) Outcomes and policy-oriented recommendations from the UNCCD 3rd scientific conference report by the Bureau of the Committee on Science and Technology

Laureano P (2012) Water catchment tunnels: qanat, foggara, falaj. An ecosystem vision. In: EN IWA specialized conference on water & wastewater technologies in ancient civilizations, pp 22–24

McGuire RH (1992) Archeology and the first Americans. Am Anthropologist 94(4):816–836

Ottmann DA (2016) Urban correlator: strategies for an ecologically adaptable urban and architectural development. Sudwestdeutscher Verlag fur Hochschulschriften AG

Roesler S (2017) The urban microclimate as artefact: reassessing climate and culture studies in architecture and anthropology. Arch Theory Rev 21(1):73–88

Rubel F, Kottek M (2010) Observed and projected climate shifts 1901–2100 depicted by world maps of the Köppen-Geiger climate classification. Meteorol Z 19(2):135

Semper G (2004) Style in the technical and tectonic arts, or, Practical aesthetics. Getty Publications

UNESCO, Centre WH (2021) Interactive map

USC (2020) Atlas of drylands design

Chapter 4
Desert Climate Design

Abstract People in hot and arid locations were driven to build their homes using climate-enhancing, resource-saving, and energy-saving measures due to a lack of biodiversity and water supplies. We discuss oasis settlements and vernacular passive cooling architecture as magnificent examples of human co-evolution with the natural ecosystem that is well-balanced. In light of the above and the requirement for urbanization in the drylands, this chapter finishes with a critical assessment of the required reduction of GHG emissions in the building industry and a reconsideration of local ecological resources climate-adaptive design concepts.

Keywords Climate · Passive design · Materials · Vernacular architecture

4.1 Climatic Constraints

Dryland zones between the 15th and 30th latitudes in the northern and southern tropics have a distinctive high-pressure belt that results in clear skies, a high proportion of direct radiation, and very low precipitation levels. Due to the low and erratic rainfall, the evaporation rate is always greater than the precipitation rate. Temperatures in the arid subtropics are high all year, reaching a peak when the sun crosses the tropical line. The climate of the desert varies according to its coastal location, continentality, and closeness to mountains. Summers and winters have significant changes in temperature amplitudes throughout the day, air moisture content, and precipitation rate. Summer temperatures are higher inland, and air humidity is substantially lower (Hausladen et al. 2012).

These climatic conditions have a tremendous impact on the conditioning of settlements and structures to artificial artefacts for comfort and wellness, which are often energy-intensive. People in hot and arid locations were driven to build their homes using climate-enhancing, resource-saving, and energy-saving measures due to a lack of biodiversity and water supplies.

'*With its feet in the water and its head in the fire*' is an old Arab adage that describes how the date palm thrives in hot and arid regions, reaching 30 m in height

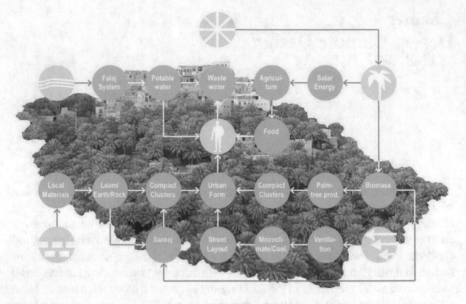

Fig. 4.1 Traditional Oasis system Misfat Al Abriyyin, Oman

and prospering even in the saltiest soil. Like the date palm, strategies were developed on how to survive as human beings within the same harsh conditions: The Oasis.[1]

4.2 The Oasis: Smart Design to Prosper in the Desert Climate

The legacy of oasis settlements encapsulates the history of entire populations along the desert belt responding to the climatic conditions through a balanced design approach to natural material systems, orientation, shape, socio-cultural and bio-economic conditions. Such communities remain magnificent examples of human co-evolution with the natural ecosystem that is well-balanced:

A typical oasis settlement (see Fig. 4.1) is surrounded by a protecting perimeter of a hydroengineered agriculture belt as the basis of the interior settlement; The oasis farmers grow an extensive array of crops, including fruits, with most of the area dedicated to groves of date palms. Within the surrounding palm groves of the oasis, the built-up footprint comprised only one-fifth of the overall space allocation. The agricultural belt depends on the above-ground irrigation system (Falaj ghiliya) that nourishes the terraces that begin at the lower edges of the dense cluster of the settlement on the south and east border of the slope. All the terraces receive their

[1] From Greek oasis, in Coptic *wahe, ouahe* "oasis," properly "dwelling place," from *ouih* "dwell". Arabic *wahah* as figurative sense of "any fertile place in the midst of a waste" (Harper 2021).

main shading through six- to eight-meter-high date palms that have a variety of crops at their base. Human and animal waste fertilize the fields. Palm trees provide resources for construction, weaving, and power generation. The urban structure of the settlement comprises around 100 housing units and supported 580 inhabitants in 1993. The topography of the place and the irrigation system explain the irregular patterns of densely clustered building structures. Narrow alleyways between the clusters allow the prevailing winds to enter the area from the wadi to the south-east and prevent the direct impact of the sun. Most structures comprise of two-storey buildings made of locally available building materials (Baumeister and Ottmann 2016).

Limestone plinths are built on the existing rock topography and continued into walls with sun-dried adobe bricks and a special pozzolanic plaster. Those loam bricks contain mainly the clayey soils of the surrounding farmland in conjunction with straw fibres for tensile strength. Slabs and roofs are constructed of quartered palm tree trunks and topped up with palm frond woven mats filled in again with clayey earth (loam). Openings are enforced through either stone or palm tree trunk lintels and fitted with wooden shutters for door and window openings. Wild olive or juniper trees of the region provide more durable timber than palm tree wood. The lower floors have few openings and mainly vertical slits in the upper wall areas to provide ventilation, heat insulation, and security from external influences. The upper floors have openings very low to the floor and ventilation slits in the upper areas of the walls to create air drafts for ventilation. The wall construction on the upper floor is thinner due to economic and structural reasons. Here the interior walls have recesses that are storage niches or light niches. This measure also takes away load from the lower floors. The main thoroughfares open onto the farmland belt on the south-east side. Other narrow alleyways are maze-like and winding through the oasis cluster contributing to a cooler microclimate from the prevailing winds from the wadi crossing to the east.

The buildings occupy elevated terraces and benefit from the cooling effect as winds pass through the oasis. The settlement is fairly protected from the harsh natural environment through the densely clustered layout. The walls of the buildings provide insulation through an 80–100 cm thick thermal mass of local (lime-)stone and earthen (loam and *Sarooj* (see Chap. 5)) construction material. Common courtyard spaces shared by the community are self-shaded by the vertical walls surrounding the court-yards. The given conditions of natural resources, namely water, prevailing winds, the solar impact, biotic and abiotic materials, have been used to create a suitable environment to support survival in the harsh and resource-scare environment of the desert. Such settlements reveal that traditional oasis systems in Oman had adapted to the environment and its available resources to remain self-sustainable over centuries (Ottmann 2016).

4.3 Vernacular Architecture as Model for Sustainable Design

Vernacular buildings serve as excellent models for sustainable design[2] lessons.

To provide for human comfort, vernacular architecture tends to respond to climatic conditions by employing passive, low-energy strategies—strategies that are integral to the form, orientation, and materiality of the buildings. This architecture also demonstrates the efficient use of local building resources, making it an excellent teaching tool for sustainable design (Weber and Yannas 2013).

Air temperature, humidity, and airflow are the primary determinants of comfort in conventional hot-dry zone design. Each has the potential to be dominant. Their impacts are not always additive, and they are rarely linear. Passive cooling systems are environmentally friendly, utilising natural elements to provide comfort to people while causing the least amount of environmental damage. They do not deplete natural resources and make use of the structure itself to create comfort. They are 'sustainable', i.e. an environment that incorporates nature and creates protection, health, and comfort through its building composition.

Such passive cooling buildings rely on natural cooling sources such as night ventilation, which lowers the building's thermal mass; evaporative cooling from courtyard water bodies and vegetation; and ground cooling, which uses underground heat exchange canals or groundwater cooling.

For summer cooling, desert buildings use proper orientation, thick walls, natural cross-ventilation, indoor and outdoor living spaces, natural and man-made shade; south-facing courts and windows with tile floors, which, when combined with the thick walls, provide for the capture and storage of heat during the winter. Summer afternoons in traditional residences are kept cool by the presence of deep basements, courtyards with gardens, ponds, and fountains. Summer rooms have open vaulted areas that face north across the courtyard, away from the sun, but winter rooms have glass doors that face south into the low winter sun. The cold night winds flow through the wind towers and open doorways at night in the summer, draining the day's heat from the house's vast mud walls. During the winter, the courtyard level and winter living rooms with timber and glass doors are used. These doors absorb the sun's heat and store in the thick mud or brick walls, keeping the interior warm at night. On summer mornings and nights when the air is colder than room air, high-rise wind towers above the roof collect passing winds and guide them down to the ground and basement spaces, cooling the internal spaces and providing ventilation to freshen the air. When the air is cool at night, it passes over the walls, floors, and ceilings, drawing the day's heat from them and cooling them for use the next day.

The house's entire form is designed to maximise its passive cooling capacity in the summer and its ability to warm in the winter when solar angles must be carefully calculated to enable optimum sun penetration into the winter room. As a result,

[2] (Environmentally) sustainable design is used here in accordance to McLennan's (2004) philosophy of creating physical items, the built environment, and services to conform with the principles of ecological sustainability.

roof design is critical, such as slopes and orientations based on the sun's path. The key principle of solar utilisation for passive systems is orientation. When it comes to maximising the solar resource, the proper direction is crucial. A correctly orientated building can maximise solar gain for human comfort heating while minimising summertime overheating with adequate design and overhangs. Using natural winter heating and reducing summer heat impacts minimises the size of heating and air conditioning equipment and the amount of energy required for these structures.

Building materials such as mud or fired brick, white lime plastered walls, and baked floor tiles absorb and store heat and cold and act as insulators to keep the heat or cool inside the building. The building's massive construction partially filled spaces and darkened walls and roofs diminish sunlight's impact. The curved domes and vaults reduce sunlight gain into the rooms and spaces below while increasing heat loss through ventilated cupolas (Hejazi 2006).

4.4 Desert Design, Building Form and Performance

Learning from the above and yet to transport this knowledge into the 21st century, structures at various scales in drylands must reflect the interrelationships between bioclimatic and cultural contexts, design considerations, and materiality, as developed in the diagram 'Interrelation of Climate, Building Design and Materiality' (Fig. 4.2).

The focus is on the delicate interaction of all six axes, which must be studied in concert in order to get a truly sustainable design solution. Climate and culture conditions are portrayed as influence elements on building design considerations as well as the surrounding Biosphere and Lithosphere environmental resources at the project site. Those factors, taken collectively, serve as important design considerations for the building's cubature, orientation, and apertures, and ultimately define the building's construction and operation processes.

As a synergy of the aforementioned, the materiality of the construction resources employed is related to structural and physical performance (thermal mass, heat transmission), as well as energetic performance across the lifecycle of the complete new building. It is now possible to optimise local ecological resources based on desired performative climate design concerns by designing material compositions according to their performance and strength desires.

4.5 Convenience Construction Systems and Global Standards

Yet, in the meantime, many building designs and construction methods in deserts adhere to globalised conformity of an international architecture language designed to

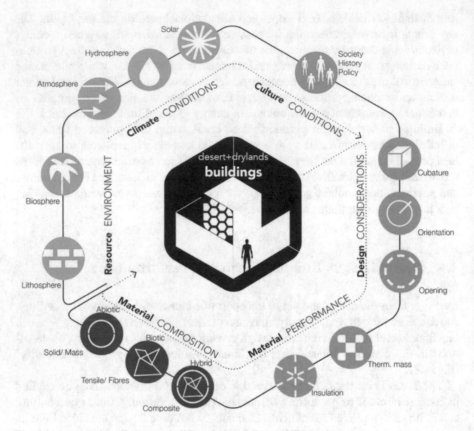

Fig. 4.2 Interrelation of climate, building design and materiality

speculate. As described in the previous chapter, the convenience of global engineering standards for interior comfort zones has occurred equally in the current construction systems. They adopt a similar attitude: from local knowledge and millennia of merit of passive design strategies, towards a global standard of conveniences such as Ordinary Portland Cement—responsible for 3% GHG emissions—concrete and steel—7.2%—construction technologies for buildings—17.5%—(Ritchie 2020) and the use of Air Conditioning Units to cool the interior (often at 70% of the energy for building operations) no matter what orientation, shape, façade or structural system. For the required reduction of GHG emissions in the building sector—particularly in climatically dry regions where the energy demand to construct and operate buildings is even higher—it is critical to reconsider local ecological resources and climate-adaptive design principles.

The various so called 'Green' or 'Sustainable' Building Rating Systems account for energy, water, and material consumption in buildings and a geared for the reduction strategy but ignore the importance of orientation, massing, surface-to-volume-ratio, and a more holistic interpretation of local material systems within the design synergy.

Traditional desert architecture can teach a way to achieve liveability and comfort through the intricate synergy of the abovementioned aspects of climate design. The adequate local resources (materials, energy and information) lay dormant as a fractal of the overall building or settlement design and form.

Hence to enrich the palette of utilising desert and drylands resources into ecological building materials, further investigations and experimentation are required to continue the knowledge of the past into the future.

References

Baumeister J, Ottmann DA (2016) Urban: organ—models for Gulf cities as Integrated ecological systems. Gulf Cities as Interfaces 107

Harper D (2021) Oasis. Online etymology dictionary|origin, history and meaning of English words

Hausladen G, Liedl P, de Saldanha M (2012) Building to suit the climate: a handbook. Birkhäuser

Hejazi M (2006) Persian architecture: conformity with nature in hot-dry regions. Int J Des Nat Ecodyn 1(2):186–196

McLennan JF (2004) The philosophy of sustainable design: the future of architecture. Ecotone Publishing

Ottmann DA (2016) Urban correlator: strategies for an ecologically adaptable urban and architectural development. Sudwestdeutscher Verlag fur Hochschulschriften AG

Ritchie H (2020) Sector by sector: where do global greenhouse gas emissions come from? Our word in data. https://ourworldindata.org/ghg-emissions-by-sector. Accessed 03 Oct 2021

Weber W, Yannas S (2013) Lessons from vernacular architecture. Routledge

Chapter 5
Climate Matters: Ecological Materials for Deserts and Drylands

Abstract Extreme bioclimatic environments necessitate extra efforts to create a habitable environment. We argue that local cultures in deserts and drylands have pioneered ecological material systems to create artificially inhabitable climate enclosures. As a result, a similar approach enhanced by technological progress in developing ecological materials for deserts and drylands is required to continue those efforts toward a sustainable future of net-zero desert and dryland architecture. The material selection criteria for this publication are discussed here, and the foresight of a tool to think new eco-efficient materials.

Keywords Ecological materials · Local resources · Innovation · Composites

5.1 Materials Development as Key Innovation

Materials have been an essential driving force for technological progress since the origins of human history. It is not for nothing that humanity's developmental epochs have been named the Stone Age, the Bronze Age and the Iron Age, i.e. after the most modern materials available at that time. With stone tools, humans were able to significantly increase the potential of their bodies to influence their surroundings. The first simple blades were made from stone. Later on, metalworking made it possible to manufacture tools and components with complex shapes, which finally ushered in the industrial revolution with the invention of the steam engine.

Since then, nothing has changed in terms of the paramount relevance of materials for society. Over two-thirds of all technical innovations can be traced back directly or indirectly to new materials (Magee 2010). This applies to almost all branches of the economy and areas of need. Therefore, materials science is just as much a key technology as it is a cross-disciplinary endeavour at the heart of sustainable development. It has long since moved beyond empiricism, which was still prevalent at the turn of the century. This was only feasible because of a better knowledge of matter's atomic structure. Today, well-functioning models aid scientists in developing materials that are precisely matched to the application, implying that humans can significantly expand the scope of their actions, just like they did at the dawn of the Stone Age.

D. A. Ottmann, *Ecological Building Materials for Deserts and Drylands*,
SpringerBriefs in Geography, https://doi.org/10.1007/978-3-030-95456-7_5

5.2 Global Materials Flows

Trends and increases in material productivity can be observed as a result of the combined effect of innovation, technical progress, and policy for resource efficiency and sustainable consumption and production. It is now commonly understood that meeting the needs of a growing global population—including housing, mobility, food, power and water, and modern consumer goods—would require considerable material and energy efficiency improvements in the global economy.

Global raw material supply and the potential for efficiency gains and material use reductions in the global economy are at the forefront of materials selection for the construction industry. The materials extraction chart in Fig. 5.1 reveals that raw material extraction has more than tripled from 1970 until now while the population has doubled. The fastest-growing group of resources was non-metallic minerals used in construction, with annual global extraction increasing from 22 billion tonnes in 1970 to about 70 billion tonnes in 2010 (UNEP 2016).

Especially for hot, arid and resource pour environments in drylands, the challenge to achieve human development and improved well-being at lower eco-footprint levels of material consumption has unique rules.

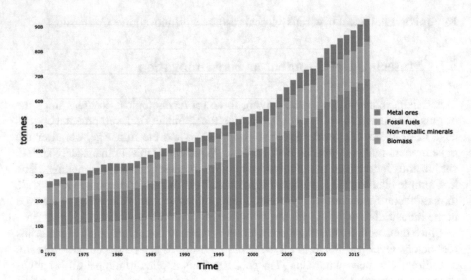

Fig. 5.1 Materials extraction, world (Vienna 2020)

5.3 The Quest for Ecologically Efficient Materials

Material processing, or the conversion of natural resources (ores, oil, biomass) or trash into materials stocks, which are subsequently processed through manufacturing and construction into goods, accounts for 30% of total global GHG emissions (Fischedick et al. 2014). The trend of materials extraction in various dryland countries indicates a massive increase in especially metal ores between 1970 and 2017. Metals and especially steel has become an ever more important construction material but at the same time is responsible for 7.2% of GHG emissions derived from iron and steel production (Ritchie 2020) To achieve a net-zero emission target by 2050 the steel production has to fall 4% annually between 2020 and 2030 (IEA 2020).

Another sticking extraction rise is the position of non-metallic minerals in particular limestone. As the main ingredient of cement in concrete its role as the primary building material for bridges, roads, and other infrastructure projects around the world, concrete emits a significant quantity of CO_2 each year.

Just the production of 'iron and steel, as well as non-metallic minerals (mostly cement)', accounts for '44% of total CO_2 emissions (direct, indirect, and process-related) from industry'; 'Chemicals (including plastics) and fertilizers, pulp and paper, nonferrous metals (particularly aluminium), food processing, and textiles' are all emission-intensive industries (Fischedick et al. 2014).

While minimizing non-renewable raw material extraction is important, eco-efficient construction and building materials must also take other factors into account. Pacheco Torgal et al. (2012) discuss the selection criteria as:

- Non-toxic materials;
- Materials with low embodied energy;
- Recyclable materials;
- Materials containing wasters from industries;
- materials responsible for low GHGs;
- Materials with high durability;
- Materials with self-cleaning ability and capable of reducing air pollution.

5.4 Desert Matters: Local Resources and Ecological Materials

Local resources must be considered within the physical environment (matter and energy) and the socio-cultural surrounds of the anthroposphere (information) where intangible knowledge has been traded and spread through oral history and secret knowledge passed on from generations. Learning from the traditional building knowledge (see the oasis example in Chap. 4) using passive design strategies the available material systems were fundamental in achieving this task. As described in previous chapters on climate culture and design, traditionally, a combination of hybrid material systems was applied: earthen (vertical) and wooden/fibrous composite (horizontal

spans) derived from the surrounding material systems, cultivated (domesticated plantation, water engineering systems) and existed natural conditions (topography, orientation, solar and lunar aspects, air movement).

Water, as a source of life for humans, animals, and vegetation in the oases, could only be channelled into communities using particular waterproof plasters and mortars like *Sarooj* pozzolanic lime cement (see Fig. 5.2 for the traditional production method). The invention of this magical waterproof lime cement can be traced back to ancient desert wisdom (see Chap. 3) as a starting point for making deserts habitable. *Sarooj* (and other descriptions for the same material in other cultures) allowed for the construction of not only water leading pipework and defence structures but was also utilized as a water-resistant roof covering and external wall plaster for the normally rapidly degrading sun-baked adobe structures, allowing entire villages to form.

Meddah et al. (2020) describe a modern (under controlled processing) production of *Sarooj* as locally engineered cementitious material in a partial replacement of Portland cement. It has the ability to enhance durability and sustainability by reducing the manufacturing energy (from 1600 °C for clinker cement to 800 °C). It comprises a new (old) energy-efficient building material to reduce the carbon footprint at the core of sustainability in construction and an essential factor of life cycle assessment (LCA).

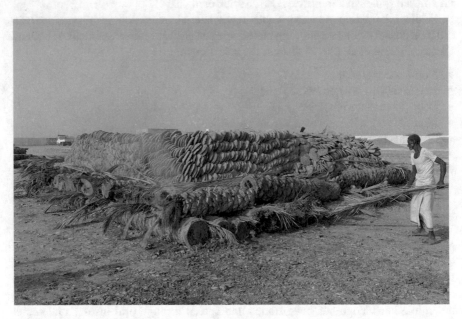

Fig. 5.2 Traditional *Sarooj* production in Oman

5.5 Classification of Materials

Inspired by material innovations such as *Sarooj* and other traditional ecological materials (e.g. loam, palm fibres, mangrove, acacia, cob) investigated in an earlier study on the 'Traditional Building Knowledge in Oman' (see Exhibition from 2011 in Fig. 5.3), this publication aims to expand options for eco-efficient building materials in drylands.

To deliver a toolset for future research, the taxonomy of materials in Chaps. 6–8 follow the MATCAT material nomenclature by Rosado et al. (2014). The following material groups can later be inserted into material flow accounting, life cycle analyses, and urban metabolism analyses in hindsight of further circular cities and economy integration.

- Non-metallic minerals (NM): listed as abiotic (mineral, earthen) in Chap. 6;
- Biomass (forestry, crops and animal products) (BM): as biotic materials in Chap. 7;
- Fossil Fuels (FF) and Metals (MM) are not considered in this publication due to the irrelevance of sustainable options for low emission, energy-efficient, and non-fossil fuel based nature of ecological materials.

In addition, we describe in Chap. 8 various hybrid materials that combine abiotic and biotic ingredients.

Fig. 5.3 Material collection at 'Traditional Building Knowledge' exhibition of Omani drylands settlements (Ottmann 2012)

As an ever-growing field of research and development, the compilation of the following materials does not claim to be complete but rather more of a starting point for the reader to investigate further.

The materials chosen were gathered with the following criteria in mind:

- Local/regional abundance;
- Potential low GHG emission;
- Relating to the vernacular and long-lasting;
- Contextual to the socio-cultural system;
- Recyclability;
- Health and non-toxicity;
- Potential as hybrid component; and
- Thermal properties.

The resulting listing of the aforementioned material groups (NM and BM) aims to support potential new composite material considerations in Chap. 9 and will later lead into an 'eCombinator' tool in Chap. 10 (see overview in Fig. 1.1).

References

Fischedick M, Roy J, Abdel-Aziz A, Acquaye A, Allwood J, Ceron J-P, Geng Y, Kheshgi H, Lanza A, Percayk D (2014) Industry

IEA (2020) Iron and steel report. International Engery Agency. https://www.iea.org/reports/iron-and-steel. Accessed 03 Oct 2021

Magee CL (2010) The role of materials innovation in overall technological development. JOM 62(3):20–24

Meddah MS, Benkari N, Al-Saadi SN, Al Maktoumi Y (2020) Sarooj mortar: from a traditional building material to an engineered pozzolan-mechanical and thermal properties study. J Build Eng 32:101754. https://doi.org/10.1016/j.jobe.2020.101754

Ottmann DA (2012) Traditional building knowledge Oman. https://storymaps.arcgis.com/stories/4cbb6650aa6342758941ec785f04b40d. Accessed 3 Nov 2021

Pacheco Torgal F, Miraldo S, Labrincha JA, De Brito J (2012) An overview on concrete carbonation in the context of eco-efficient construction: evaluation, use of SCMs and/or RAC. Constr Build Mater 36(C):141–150. https://doi.org/10.1016/j.conbuildmat.2012.04.066

Ritchie H (2020) Sector by sector: where do global greenhouse gas emissions come from? Our word in data. https://ourworldindata.org/ghg-emissions-by-sector. Accessed 03 Oct 2021

Rosado L, Niza S, Ferrão P (2014) A material flow accounting case study of the Lisbon metropolitan area using the urban metabolism analyst model. J Ind Ecol 18(1):84–101

UNEP I (2016) Global material flows and resource productivity. Assessment report for the UNEP international resource panel United Nations Environment Programme, Nairobi

Vienna W (2020) Material flows by material group, 1970-2017. Visualisation based upon the UN IRP global material flows database. Vienna University of Economics and Business. http://wwwmaterialflowsnet/visualisation-centre. Accessed 28 Sept 2019 (Google Scholar)

Chapter 6
Abiotic Materials

Abstract This chapter seeks to catalogue abiotic resources found in deserts and drylands which are comprised of raw non-biotic materials, i.e. raw materials that are derived from non-living organisms. The source of material resources is essentially focused on hyper-arid, arid, semi-arid and sub-humid regions characteristic of drylands and deserts. With the objective of promoting existing ones and establishing new building materials, this chapter records materials in their raw format as well as their existing use as a construction material if applicable. Materials are classified under five basic applications: structural system, infill, cladding or skin, insulation or thermal mass and binding agent. Advantages and disadvantages consider criteria such as abundance, low GHG emission, resistance, durability, recyclability, toxicity, and thermal properties.

Keywords Abiotic matter · Minerals · Ecological resources · Drylands · Building

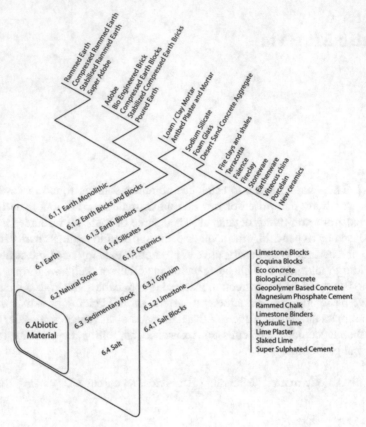

Abiotic materials overview

6.1 Earth

6.1.1 Earth Monolithic

Compressed Rammed Earth

Raw Materials:
 Earth containing less clay (15–30% by volume) and/or small rock (fist size) (Haar 1992).

Location:
 Hyper-arid, arid, semi-arid, sub-humid regions.

Use:
 Structural systems.

Description:

Like many other earth techniques, rammed earth, also known in French as pisé de terre or simply pisé, has been utilised for many years over the world. To create a uniform humid mix, the earth is completely combined with water. This moist earth is poured in thin layers into a shape and then pushed in place to increase solidity. The compressive strength and water resistance increase as density rises.' A small quantity of movable, temporary formwork is required. Traditionally, ramming was done by hand, but it can now be done manually or mechanically—ideally, a low-capacity machine that does not require an air compressor (Middleton 1982).

Construction must take place during dry weather, but with plenty of water available (Fielding 2012). The worldwide heritage of rammed earth construction has demonstrated that buildings of every size, from single to multi-story, can be built to last (AVEI 2021).

Advantages:

Rammed earth has a superior thermal comfort. It is recyclable and clean to produce. Community participation is high.

Disadvantages:

The method is slow and inflexible. High maintenance is needed.

Stabilised Rammed Earth

Raw Materials:

Earth (gravel, sand, silt and clay) and cement (5–10%).

Location:

Hyper-arid, arid, semi-arid, sub-humid regions.

Use:

Structural systems.

Description:

Stabilised rammed earth is a type of rammed earth that contains a small amount of cement (usually 5–10%) to improve strength and durability. A mixture of gravel, sand, silt, clay, and sometimes cement is compacted between formwork in a sequence of layers to create stabilised rammed earth. Stabilized rammed earth walls require minimal additional protection, however, they are frequently covered with an air-permeable sealer to extend the material's life—this varies depending on the situation. Generally, conventional concrete slab or strip footings are employed, depending on soil conditions (Downton 2013).

Rammed earth, as well as machinery, benefited greatly from soil stabilisation. Pneumatic rammers have taken the place of the conventional wooden rammer. Heavy wooden formworks gave way to lighter composite formworks comprised of plywood, wood, steel, and occasionally aluminium. Pneumatic rammers, dumpy loaders, mixers, ban conveyors, and other tools made it possible to build faster and with higher quality. The majority of structures are constructed with pier walls,

which means that the walls are built to their full height all at once. This method of construction completely altered the structure's design pattern (AVEI 2021).

Advantages:
Cement use is low. Community participation is high.

Disadvantages:
The method is slow and inflexible. Could provide the ideal environment for the growth of bacteria.

SuperAdobe

Raw Materials:
Earth, sandbags, barbed wire.

Location:
Hyper-arid, arid, semi-arid, sub-humid regions.

Use:
Structural systems, infill.

Description:
SuperAdobe is a sandbag-like substance that is filled with soil in a tubular roll. The earth tubes are held together by barbed wire. Later, stabilised earth plaster is applied to the earth tubes (AVEI 2021). For the sandbags, almost any earth can be used; natural and synthetic materials can be utilised, but a synthetic, low UV (ultra-violet) resistant, degradable substance is preferable.

Long or short sandbags are filled with on-site dirt and stacked in layers or long coils (compression), with strands of barbed wire inserted between them to serve as mortar and reinforcement (tension). Cement, lime, or asphalt emulsion can all be used as stabilisers. Vaults and domes can be made out of super adobe. These structures can be used for a single season before being returned to the earth, or they can be stabilised, waterproofed, and finished as permanent residences. Structural arches, domes, and vaults, as well as traditional rectilinear designs, can all benefit from the approach. The same approach can be used to construct silos, clinics, schools, landscaping components, and infrastructure such as dams, cisterns, roads, bridges, and coastal and watercourse stabilisation (Khalili 2014).

Advantages:
There is no heavy lifting, no expensive equipment, and a flexible and fast construction. They can be built alone or as a group. Sandbags add flood resistance, while the earth itself provides insulation and fireproofing. In a temporary building, the bags are allowed to degrade and the building returns to earth. They are also hurricane and earthquake resistant.

Disadvantages:
The choice of bags can contain toxic chemicals, be UV-irresistant, and not durable.

6.1.2 Earth Bricks and Blocks

Adobe

Raw Materials:
 Clay [salt-free earth with clay content in excess of 50% by volume (Haar 1992)], fibre.

Location:
 Semi-arid.

Use:
 Structural system, infill.

Description:
 Hand-moulded soil blocks that are sun-dried after being strengthened with a binder such as straw. Mud mortar is used to lay the blocks, and the wall is finished with mud render. Annual maintenance, such as plastering a fresh layer of mud, is frequently required, especially in locations with significant rainfall (Fielding 2012). When soil no longer sticks to metal tools or, in scientific terms, when it reaches its liquid limit, it is at the proper moisture level for moulding adobe blocks. Before being moulded, clayey soils require the use of straw (or other fibrous materials) to distribute the cracking that will occur as the soil dries. The straw should be between 50 and 75 mm long, and each block should include about as much straw as can be scooped up in one hand to ensure sharp emerges, soil with the appropriate moisture content is poured in the mould and squeezed into the corners. The mould is lightly greased before being filled with soil. The surplus soil is screeded away and added back to the pile. The mould is removed from the block right away. One simple face of the mould can be replaced with the required pattern to create a textured face. The blocks are turned to one side after approximately a week and allowed to cure for another week or two before being piled to dry entirely before being utilised. In good weather, the blocks should be cured for at least four weeks (Middleton 1982).

Advantages:
 Adobe walls can provide moderate to high thermal mass (Downton 2013). They are resilient to all but most severe weather conditions (Haar 1992) and generally have excellent fire resistance.

Disadvantages:
 Vulnerable to wasp or ant infestations (Haar 1992). The technique requires a lot of water, which can be a problem in dry areas.

Bio-Engineered Brick

Raw Materials:
 Bacteria, sand, calcium chloride, urine.

Location:
 Hyper-arid, arid, semi-arid, sub-humid regions.

Use:
 Structural system, infill.

Description:
 Bio-engineered bricks are developed at room temperature in a laboratory. Microbial-induced calcite precipitation, or MICP, is a process in which bacteria on sand exploit a sequence of chemical processes to bind the grains together like glue. The resulting mass looks like sandstone but has the strength of fired-clay brick or perhaps marble, depending on how it is formed (Mok 2010).
 Because sand is abundant in nature, it is used as a brick substrate. After that, a liquid cement is made using bacteria to offer a crystal-forming environment, a nitrogen source, bacteria food, calcium source, and water. The solution is poured over a sand bed in a mould and added to several times over the course of five days until a solid material has developed. Bacteria die when their food and water sources run exhausted. To save water and catch a byproduct of the bacteria as a natural fertiliser, the irrigation solution is totally recycled in a closed loop system (Matus 2013).

Advantages:
 They are an alternative to environmentally draining kiln-fired bricks as they are a zero-waste building material made with urine, which hardens at room temperature eliminating the need to heat them at high temperatures and consequently lowering carbon dioxide emissions.

Disadvantages:
 The process produces large amounts of ammonia, which microbes convert to nitrates, which can eventually poison groundwater supplies.

Compressed Earth Blocks

Raw Materials:
 Natural sands, loam without other additives.

Location:
 Hyper-arid, arid, semi-arid, sub-humid regions.

Use:
 Structural system, infill.

Description:
 The first attempts at compressed earth blocks (CEB) were with little wooden moulds with hand rammers. The Cinvaram, forerunner of steel manual presses, invented mid last century, could produce very regular blocks in shape and size, denser, stronger, and more water resistant than normal adobe.
 In the twentieth century, CEB technology played a significant role in the international renaissance and promotion of earth construction. Non-stabilized clay (unburnt) bricks are made by hand or in a factory. The raw dirt is slightly moistened before being put into a steel press and crushed manually or mechanically. It is a step forwards from traditional rammed earth construction (AVEI 2021). Blocks made with a single

material mix are produced by traditional compressed earth block presses) (Egenti and Khatib 2016).

Advantages:
The raw materials needed are easy to source and the production method is relatively inexpensive.

Disadvantages:
CEB are not suitable for high-rise buildings and wide spans.

Stabilized Compressed Earth Bricks

Raw Materials:
Soil (not rich in clay), stabilising agent (cement, lime, jute, coir, sisal, bamboo, wood, palm leaf, coconut leaf, banana leaf, coir dust, cotton or grass etc.)

Location:
Hyper-arid, arid, semi-arid, sub-humid regions.

Use:
Structural system, infill.

Description:
Where suitable clay-rich soils are unavailable, salt free and cement (at a ratio between 5:1 and 10:1 depending on sand particle size) can be used to produce bricks, with simple timber forms. Materials used for footings and sub walls should not contain clay or loam as they soften a little when affected by rising damp to allow entry by ants and wasps. Sand-cement and stone are the more suitable materials here (Haar 1992).

Blocks are made using a block press that provides a high compressive effort. Soil stabilisation allows for taller structures with thinner walls that have better compressive strength and water resistance. The blocks must be cured for four weeks after production using cement stabilisation. After that, they can dry completely and be utilised with a soil cement stabilised mortar much as regular bricks. It is recommended that load-bearing walls be built without the use of intermediate columns (with a high cement content). This necessitates a shift away from dry-jointed interlocking earth brick wall building. Plain rectangular bricks provide you a lot more freedom when it comes to designing diverse layouts. They require strict dimensional control because they are modular systems. Where columns are required, they can be built as reinforced piers. Although this approach uses mortar, a 10 mm mortar joint can be lime-based or use only a small percentage of cement, in contrast to standard joints on a concrete-block building (Fielding 2012).

Advantages:
They are cheaper than concrete blocks and allow for thinner walls with compressive strength and water resistance.

Disadvantages:

Cement stabilised blocks have very poor shear strength, which is critical in the case of earthquakes (AVEI 2021).

Poured Earth

Raw Materials:

Soil (sandy or gravely) / Stabilising Agent (washing powder, ashes, soapnut, or classic concrete plasticizers).

Location:

Hyper-arid, arid, semi-arid, sub-humid regions.

Use:

Infill.

Description:

Lateritic soil can be mixed with cement to make a 'slurry,' then poured into a mould and cured with some vibration (Newton 1987). The poured earth technique is a cutting-edge construction method that uses earth in its plastic state. If mastered, this approach can minimise construction time and be a more convenient way to construct with earth than compressed earth bricks or rammed earth.

The earth is put into formworks in a liquid state, much like concrete. The soil should have very sandy or gravely properties and should be stabilised. This is a relatively new approach that is rarely used. The reason for this is that the soil's high water content will cause significant shrinkage as it dries. As a result, the wall will crack significantly. The goal is to be able to pour earth in the same way that concrete is poured, resulting in the same workability. Earth concrete must be very plastic in order to achieve good workability. However, if you add too much water, it can weaken the structure and cause shrinkage and cracks when it dries.

As a result, the key challenge is to liquefy the ground without adding too much water. The Auroville Earth Institute has been planning and conducting tests, seeking the proper admixtures and additions while juggling amounts and quantities. They are testing a range of additives, including washing powder, ashes, soapnut, and traditional concrete plasticizers (AVEI 2021).

Cement (at 5 to 10% by volume depending on soil qualities), horizontal reinforcement, and control joints can be added to poured mud walls to reduce shrinkage cracking (Haar 1992).

Advantages:

No significant shrinkage.

Disadvantages:

Strength is greatly reduced. Adding too much water will weaken the structure and result in shrinkage and cracks when drying.

6.1.3 Earth Binders

Loam/Clay Mortar

Raw Materials:
 Clay may be mixed with animal dung.

Location:
 Semi-arid regions.

Use:
 Cladding.

Description:
 The most suitable and cost-effective mortar is mud mortar made from the same material as adobe bricks. The dirt for the mortar should be thoroughly screened to ensure that no stones larger than 6 mm remain in the mix. Straw should be avoided (Practical-Action 2021). To make a mud mortar, simply mix clay soil with water until it becomes pliable (workable). A mud mortar dries quickly once applied, eliminating the need for lengthy curing operations.

 Many different types of soil can be used in the construction of mud mortars, which are still frequently utilised in many regions of the world. Each type of soil has unique features that make it suited for diverse applications to varying degrees. Most soils, on the other hand, may be made to work best by using certain preparation techniques and construction processes, which may include the inclusion of stabilisers or other chemicals. Soil-based mortars can now be utilised consistently in a wide range of construction applications thanks to recent advancements in soil building practice. Mud mortars are commonly used to bind adobe blocks in wall construction, but they can also be used to bind walls of field or cut stones, compressed earth blocks, and fired clay bricks.

 Mud mortars are also used to construct arches, vaults, and domes made of various materials, and the fact that they can be constructed without any sort of shuttering is a testament to mud mortar's adhesive power. Mud-based mortars can be used on brickwork, monolithic walls, wattle and daub, flat roofs, vaults, and domes, among other things. They serve as a waterproofing coat as well as improve the aesthetic of a structure (Practical-Action 2021).

Advantages:
 Benefits include good bond to compatible surfaces, relatively high compressive strength and ease of preparation allowing them to be used in a range of applications.

Disadvantages:
 Depending on the exposure conditions, external renders may deteriorate. They require frequent upkeep and repair, but if well-cared-for, can last a lifetime. Mud mortars have low tensile strength and are susceptible to shrinkage.

Antbed Plaster and Mortar

Raw Materials:
 Antbed.

Location:
 Arid, semi-arid.

Use:
 Cladding.

Description:
 Termites are the most effective earth builders. It is in their nature to construct with earth. Termites use their saliva to stabilise the soil. The latter is sticky, as it is used to break down cellulose, and thus binds soil grains together. This enables them to create such marvels. Termites can also be thought of as the most effective air conditioners. Their hills are designed to keep them alive by regulating temperature and moisture (AVEI 2021). In crushed anthills, the chemicals in the termite's soil-binding bodily fluid are still present (or antbed). Stone walls, home floors, tennis courts, and airstrips can all benefit from puddles and re-laid antbed as a mortar. Many of these structures have withstood decades of wet season exposure and are still operational today. Wasps may be attracted to the fibre depending on the region (Haar 1992).

Advantages:
 Antbed can withstand wet season exposure for decades.

Disadvantages:
 Anthill soil has been found to be likely to crack when used for plastering the external walls of houses. Materials made from anthill soil may not be as durable or hard wearing as those made from other materials. May attract wasps in certain areas.

6.1.4 Silicates

Sodium Silicate

Raw Materials:
 Sodium oxide (Na_2O), silica (silicon dioxide, SiO_2).

Location:
 Hyper-arid, arid, semi-arid, sub-humid regions.

Use:
 Cladding, binding agent.

Description:
 Sodium silicate, or water glass, is a clear, colourless to light brown sodium silicate solution with various SiO_2 to Na_2O ratios. Sodium silicates are inorganic compounds that can be used for a variety of purposes. Core binders, paint/pigment extenders, and

coating extenders are all good uses for sodium silicates. It is utilised as a concrete setting addition in mining and construction (Coogee-Chemicals 2014).

They are also utilised to keep mortars and cements dry. Silicate binders' inorganic glass structure makes them ideal for making adhesives and mortars. Acids and solvents are not a problem for them. They are completely incombustible and can meet the most stringent heat resistance standards. Sodium silicate can be used as a paint or plaster at low temperatures, in high humidity, and even on wet surfaces (vanBaerle 2014).

Because of their low cost, inorganic nature, ease of handling, rapid controlled set, high strength, insolubility (when aired), and chemical stability, sodium silicates are commonly utilised as high-temperature adhesives and binders (Schundler 2014).

Advantages:
Fire-retardant, water-repellent, low-cost, and widely available.

Disadvantages:
Sodium silicates are alkaline materials and pose hazards to the skin and eyes.

Foam Glass

Raw Materials:
Glass cullet and one or two types of adjuvant (foaming agent, limestone, calcium carbide, or coke).

Location:
Hyper-arid, arid, semi-arid, sub-humid regions.

Use:
Insulation.

Description:
The raw material for foam glass is cullet and one or two types of adjuvant (foaming agent, limestone, calcium carbide, or coke). The raw material is roasted at 800 °C until a large number of closed and unconnected pores are generated, after grinding, blending, and fitting die. The foam glass has a high porosity of up to 80–90%, with each pore measuring 0.1–5 mm in diameter. Low thermal conductivity, excellent compression strength, good frost resistance, and higher durability are all advantages of foam glass. This material can be used to construct walls, control heat in refrigeration equipment, and as a floating and filtering material. It is a high-tech heat-insulating material that is simple to cut and instal. Foam glass is most effective as a stiff insulator. It is suited for use as insulation in roofs, walls, and traffic areas such as flat roofs or floors, due to its outstanding structural capabilities, when other insulation products may be compressed, resulting in an uneven surface and loss of insulating properties (El-Haggar 2007).

Advantages:
Foam glass has high fire resistance, and because of its low water absorption and water vapour transmission, it retains its insulating characteristics even when wet,

unlike many other types of insulation. It is also rodent-proof, a good sound absorber, non-toxic, and non-water absorbent.

Disadvantages:
Foam glass insulation is fragile. It is susceptible to vibration-induced damage. The cost of the insulation is expensive compared to other insulations with similar insulation properties and installation costs are higher due to the fragile nature of the insulation (Solas and Kelly 2014).

Desert Sand Concrete Aggregate

Raw Materials:
Fine sand, water, mineral binders, additives.

Location:
Hyper-arid, arid, semi-arid, sub-humid regions.

Use:
Structural systems.

Description:
Due to its fineness, geometrically circular grain spectrum, and smooth surfaces, desert sand is unsuitable for concrete production. Experts, on the other hand, have been working to develop a reliable system for large-scale manufacture of concrete aggregates from fine sand. The basic concept is to grind fine sand even finer, then granulate the sand flour with water, mineral binders, and special additives into pressure balls up to 15 mm in diameter. The conversion of fine sand flour to pellets can be accomplished in existing granulating facilities, therefore no additional machinery or plant technology is required. The concrete produced is suitable as both mass building materials and for highly stressed concrete structures (Rosenlocher and Halser 2019).

Advantages:
The desert sand granules are used to produce concrete that is up to 25% lighter, hardens faster and have twice the strength of standard concrete 24 h after production.

Disadvantages:
No disadvantages are noted.

6.1.5 Ceramics

Raw Materials:
Silica sand, clay, water.

Location:
Hyper-arid, arid, semi-arid, sub-humid regions.

Use:
 Cladding.

Description:
 Ceramics are crystalline inorganic and non-metallic materials and are formed mostly of silica sand, a clay binder, and up to 30% water. They are burnt at a higher temperature than bricks, causing the silica to re-crystallize, resulting in a glassy material with increased density, hardness, strength, chemical and frost resistance, and superior dimensional stability. The product is then powder-moulded before being fired for days or weeks at temperatures between 1800° and 2000°. Ceramics can be glazed with a glass-like finish or have a fired look.

 Fire clays and shales, terracotta, faience, fireclay, stoneware, earthenware, vitreous china, porcelain, or modern engineered ceramics with a better purity than traditional ceramics are examples of different types of ceramics. Ceramics referred to as 'technical' or 'engineering' do not utilise clay. Powders are produced, then cast, crushed, extruded, or moulded into the desired shape and strength (Pilkington 2019).

Advantages:
 Hardness and compression strength, ability to withstand chemical erosion and resistance to extremely high temperatures.

Disadvantages:
 Ceramic materials are brittle and weak in shearing and tension.

6.2 Natural Stone

Raw Materials:
 Stone

Location:
 Hyper-arid, arid, semi-arid, sub-humid regions.

Use:
 Structural systems, infill, cladding.

Description:
 The term 'natural stone' refers to stone that has been removed straight from the Earth's crust. Natural stone can be classified into three categories based on how it was formed: Sedimentary rock (sedimentites), Igneous rock (magmatites), and Metamorphic rock (metamorphites). Granite, sandstone, and marble are among the 30 types of stone that fall into these three categories (Herzog et al. 2017). Numerous factors determine the selection of natural stone for a particular construction purpose, including aesthetic qualities: colour, texture, grain size, strength and durability, ease of working and cost of preparing and fixing in position, accessibility of deposit, transport costs,

general acceptance of the stone by architects, designers and building owners. In addition, stones vary widely in their physical properties and a good understanding of the significance of these properties is required to both build effectively and to maintain and conserve buildings of value. Lime can be used as a mortar (Young 1993). Natural stone can be dry stacked to easily build a foundation or load-bearing wall. It can be dry laid for paving on gravel or sand with no setting materials—allowing for easy repurposing (Sajkovic 2014).

Advantages:
 Natural, low-maintenance, and exceptionally durable. Thermal mass in natural stone reduces heating and cooling loads.

Disadvantages:
 High cost of materials and labour. Heavy nature demanding a structural substrate and, in some cases, additional fixtures.

6.3 Sedimentary Stone

6.3.1 Gypsum

Raw Materials:
 Calcium sulphate, water of crystallization.

Location:
 Hyper-arid, arid, semi-arid, sub-humid regions.

Use:
 Cladding.

Description:
 The most common sulphate mineral is gypsum. Calcium sulphate is a white powdered natural mineral (Handreck 1993). The mined gypsum rock, usually grey to white, is the starting point for all gypsum products. The basic mineral, calcium sulphate, is chemically mixed with crystallisation water to form $CaSO_4 \cdot 2H_2O$. Water accounts for about 20% of the weight of gypsum rock and makes it fire resistant. After being mined or quarried, gypsum rock is crushed, dried, and ground to flour fineness before being calcined to drive off the majority of the chemically mixed water as steam. This calcined gypsum, also known as plaster of Paris, is then mixed with water and other components to form a gypsum board or gypsum plaster or cement. Gypsum has long been the primary raw material for drywall and plaster; 'synthetic' gypsum production increases. Synthetic gypsum is a byproduct of a manufacturing process. Calcium sulphate (gypsum) and water are formed when calcium and water in wet limestone mix with sulphate in a coal-burning furnace's exhaust (Mercer 2010).

Advantages:
 Fire-resistant qualities and excellent resistance to airborne and impact sound transmission without excessive bulk or weight.

Disadvantages:
 Difficulty in curved-surface application and low durability when subject to damage from impact or abrasion.

6.3.2 Limestone

Limestone Blocks

Coquina Blocks

Raw Materials:
 Limestone composed of pieces of coral and shells.

Location:
 Hyper-arid, arid, semi-arid, sub-humid regions.

Use:
 Infill.

Description:
 Coquina blocks are limestone blocks formed of coral or shell fragments. The shell deposits have consolidated into soft coquina limestone over time. Rainwater dissolves little amounts of calcium carbonate, which makes up the shells, on a regular basis. The calcium carbonate precipitates as calcite crystals when the water evaporates, binding the shells together. Coquina is soft when mined and may be easily moulded into blocks. It might be gold or light brown in colour depending on where it is extracted from the ground (Dillon 2012). Walls, tiny buildings, and monuments have all been built from coquina blocks. Coquina can persist for decades in many applications, but it finally crumbles and collapses. If the rock is plastered or parged, its failure can be delayed (King 2014).

Advantages:
 Coquina blocks are cut directly from the quarry and are ready to use. They also have very good insulation characteristics (WAVIN 2014).

Disadvantages:
 Coquina blocks have extremely low compressive strength compared to common building stone, this is likely due to their friable and very porous nature (Knab and Clifton 1988).

Ecological Concrete

Biological Concrete

Raw Materials:

Conventional carbonated concrete (with a pH of around 8) or magnesium phosphate cement, biological organisms (certain families of microalgae, fungi, lichens and mosses).

Location:

Hyper-arid, arid, semi-arid, sub-humid regions.

Use:

Structural systems, cladding.

Description:

This vertical multilayer concrete's unique feature is that it works as a natural biological support for the growth and development of certain biological species, specifically microalgae, fungi, lichens, and mosses. Other characteristics that determine the bio receptivity (the ability of a material to be colonised by living organisms) of the material, such as porosity and surface roughness, have been adjusted in order to create the biological concrete. The end result is a multilayer element in the form of a panel that includes three layers in addition to the structural layer: the first is a waterproofing layer that sits on top of the structural layer, protecting it from damage caused by water seeping through. The biological layer, which encourages colonisation and allows water to accumulate within it, is the next layer. It works as an internal microstructure, assisting moisture retention and evaporation; because it can absorb and retain rainwater, this layer aids biological organism development. The final layer is a reverse waterproofing layer with a discontinuous covering. This layer allows rainwater to enter but keeps it from departing, redirecting the outflow of water to where it is needed for biological growth (UPC 2012).

Advantages:

Because of its biological layer, the concrete absorbs CO_2 and so decreases it in the atmosphere. It has the ability to trap solar radiation, allowing for the control of thermal conductivity within structures based on the temperature. The biological concrete serves as both an insulator and a temperature regulator (UPC 2012).

Disadvantages:

Some bacterial strains used are considered pathogens and cannot be directly applied in building structures like houses and offices because of health concerns (Mohanadoss et al. 2015).

Geopolymer Cement

Raw Materials:

Alumina silicate material (calcined, kaolinitic, lateric clays; volcanic rocks; industrial by-products like blast-furnace slag or coal fly ashes), a user-friendly alkaline reagent (sodium or potassium soluble silicates with a molar ratio MR $SiO_2:M_2O >$ 1,65, M being Na or K) and water (Davidovits 2013).

Location:

Hyper-arid, arid, semi-arid, sub-humid regions.

Use:
 Structural systems.

Description:
 Invented by material scientist Joseph Davidovits, a geopolymer cement is a binding system that hardens like conventional Portland cement at room temperature. If a geopolymer compound requires heat setting, it may be referred to as a geopolymer binder rather than a geopolymer cement. Geopolymer cement is an inorganic polymer that can be used in transportation infrastructure, building, and offshore applications as a viable alternative to traditional Portland cement. It is made from minimally processed natural resources or industrial by-products, which considerably reduces its carbon footprint while also being extremely resistant to many of the durability difficulties associated with ordinary concrete (Davidovits 2013).
 Geopolymers are not only low in production cost due to abundant raw materials, energy-efficient and environmentally beneficial, but they also have a higher relative strength, outstanding volume stability, longer durability, improved fire resistance, and a simple manufacturing method (Li et al. 2004). They have also been discovered to be acid and sulphate resistant (Srinivasan and Sivakumar 2013).
 Geopolymer cements do not use calcium carbonate and produce significantly less CO_2 during production, ranging from 40 to 80% to 90% less CO_2 than Portland Cement (Davidovits 2013). Apart from carbon emission reductions, Deventer (2014) describes another environmental benefit in the utilisation of recovered industrial waste, which reduces the need for raw material quarrying. One of the constituents in geopolymer could be kaolinite. Kaolinite is a clay mineral that belongs to the industrial minerals group and has the chemical formula $Al_2Si2O_5(OH)_4$. It is a silicate mineral with layers. China clay, white clay, or kaolin are all terms for kaolinite-rich rocks (Geiger 2011). Through the geopolymerisation new materials with ceramic-like structures and properties can be enabled at much lower production temperatures, which opens a plethora of new energy-efficient mineral-based polymers.

Advantages:
 High temperature and fire resistance, durability and a significantly reduced carbon footprint compared to Portland cement; can form a strong chemical bond with all kinds of rock-based aggregates and withstands acidic and salt environments.

Disadvantages:
 Geopolymer cements cure more rapidly than Portland-based cements. So far not standardised.

Magnesium Phosphate Cement

Raw Materials:
 Magnesium oxide (MgO) particles, fly ash (or other), phosphate.

Location:
 Hyper-arid, arid, semi-arid, sub-humid regions.

Use:
 Structural systems.

Description:
 Magnesium cement is an artificial stone made from an acid–base reaction of magnesia and phosphates. It possesses some properties that Portland cements do not possess. Therefore, can be utilized in the field in which Portland cements are not suitable. It is a very quick setting, has high early strength. It recycles a lot of non-contaminated industrial waste and organic waste into building materials. It stabilizes toxic and radioactive waste and has very good durability, including chemical attack resistance, Deicer-scaling resistance, permeation resistance. The lower alkalinity of magnesium cements matrices (pH value 10–11) makes them potentially better suited to vegetable fibre reinforcement. The fly ash used in magnesium phosphate cement can be over 40% by mass (twice the amount used in Portland cement). Magnesium cements can combine fly ash that is not suitable to be used in Portland cement because of its high carbon content and other impurities. Acid blast-furnace slag, red mud (the reside of alumina industry) or even tails of gold mine can also be used instead of fly ash. Magnesium cement is very suitable for repairing highways, airport runways and bridges that are used for busy transportation. The short waiting time for repairing means a lot of cost saving. In addition, their high durability, such as higher freezing–thawing and scaling resistance, low permeability, higher abrasion resistance, higher ability of sulphate attack resistance makes them suitable for severe environments, such as frosty areas and corrosive conditions (Li et al. 2004).

Advantages:
 MPC has the advantages of fast setting and hardening, rapid strength gain, superior corrosion resistance, low dry shrinkage, low permeability, and good compatibility with impurities and contaminants when compared to standard Ordinary Portland Cement.

Disadvantages:
 Due to the relatively low internal pH of MPC and the high cost, large-scale application is limited. Disadvantages also include unfamiliarity of material properties and proposed formulations, insufficient documentation and lack of track record (Wang et al. 2020).

Rammed Chalk

Raw Materials:
 Chalk or calcium carbonate ($CaCO_3$), a form of limestone.

Location:
 Hyper-arid, arid, semi-arid, sub-humid regions.

Use:
 Structural system, infill.

Description:

Rammed chalk is a type of rammed earth construction found in some parts of the UK, such as Wessex, where suitable chalk deposits are plentiful. Walls are made from chalk rubble rather than clay laden subsoil, yet the method of construction is similar to rammed earth. Before ramming, the dug chalk is broken down into bits no larger than 50–75 mm. The majority of rammed chalk structures were constructed with pure chalk rubble rather than a clay chalk mix (Pearson 1992). Chalk is a sedimentary rock that has been around for 70 to 100 million years. It was made up of the remains of small shellfish (foraminifera) that were bonded together by algae's lime secretions (coccoliths). Chalk differs significantly from the clay-bearing subsoils used in natural rammed earth. The plasticity index of chalk is often substantially lower, with plastic and liquid limits of roughly 21% and 27%, respectively. Rammed chalk has a lower density than natural chalk, ranging between 1300 and 1720 kg/m3 (Pearson 1992). Chalk takes a long time to dry because of its tiny particle size and natural inclination to trap water. A solution of sodium silicate can be applied to the walls to prevent dusting while having no effect on their ability to withstand humidity (EBUKI 2014). If at all possible, keep the chalk out of the rain during the drying process.

Advantages.

Chalk will continue to dry and solidify for years after being built into the walls.

Disadvantages:

Unless a hole is built or the surface is coated with a silicate or other 'vitrifying' fluid in exposed situations, new chalk walling is likely to enable moisture penetration under the pressure of the wind (Clough 1920).

Limestone Binders

Lime Plaster

Raw Materials:

Hydraulic or hydrated lime, water, sand, fibres (e.g. straw, animal hair or manure). Possible additive: cactus juice (e.g. Prickly Pear—*Opuntia*) (Stouter 2013).

Location:

Hyper-arid, arid, semi-arid, sub-humid regions.

Use:

Cladding.

Description:

Lime plaster can be made from either hydraulic or hydrated lime and is made by adding an excess of water to quicklime (burning limestone, marble, chalk or shell at above 900 °C to drive off carbon dioxide creates quicklime). Hydraulic lime plaster will set underwater within hours or days, making them impractical, whereas non-hydraulic lime plaster will remain plastic and improve with age. Hydraulic lime plaster forms a light, clean, and durable surface resistant to weather and mould. A thin layer attaches well to walls of earth and other natural materials. Every 4 or

5 years the plaster needs a thin coat of limewash to maintain its strength. The juice of a cactus with flat leaves can help lime plaster resist weather (Stouter 2013).

The proportions of lime/aggregate in suitable mixtures can range from more than 1:3 to 2:1. Uniformly distributed animal hair or vegetable fibres (straw, reed, manilla hemp, jute, sisal, and even sawdust) can be added for tensile strength. Because the alkalinity of the lime damages the protein in the hair, hair should be added to the plaster immediately before distributing (Bennett 2002).

Lime plaster can be applied to a variety of surfaces, ranging from a simple brick wall to a wooden lath. The surface receiving the lime plaster should be well prepped and cleaned, free of dust and other debris. The overall performance of a long-lasting defect-free lime render will be influenced by strong sun, wind, frost, and rain. Lime plasters should never be allowed to dry too quickly since the lime ingredient in the substance causes a certain amount of carbonation. The controlled process of a lime mortar completing the chemical return of the hydroxide of lime back to calcium carbonate is referred to as carbonation.

Advantages:

It shrinks and swells with heat in a similar way to earth. A thin layer of lime plaster on earth will not suffer serious cracks like cement stucco. It is also easy to repair lime plaster with a thin layer of plaster or limewash. Lime plaster protects earth walls from rain, but it also allows the walls to dry out.

Disadvantages:

Frost damage to lime mortars can be a problem and needs careful evaluation prior to carrying out work during the winter months low strength; corrosive; sensitive to moisture; long setting and hardening and high energy production are other issues.

Slaked Lime

Raw Materials:
 Limestone or shells, or other material high in calcium carbonate, water.

Location:
 Hyper-arid, arid, semi-arid, sub-humid regions.

Use:
 Binding agent.
 Description:
 Limestone, shells, or other material high in calcium carbonate is burnt in a kiln, where the heat drives off carbon dioxide, leaving calcium oxide, also called *Quick-lime*. Quicklime is a dry powder that is highly reactive with water. Calcium oxide reacts with water in an extremely heat-producing reaction, a process called 'slaking'. Because hydrogen links to the calcium oxide molecule in the water, the result is hydrated lime or calcium hydroxide. Calcium hydroxide is available as a powder or a putty. When calcium hydroxide (in powder or putty form) is exposed to air, it combines with carbon dioxide in the air and returns to its original state as calcium carbonate. Apart from the energy used in the kiln, lime is carbon neutral (Koko 2014).

Slaked lime is suitable for many uses in the building trade. This in general includes its use in mortars and plasters (Lazell 1915).

Advantages:

Lime absorbs moisture thus stabilising internal humidity and allowing the building to breathe. Small scale production of lime is possible. Lime provides high durability and good workability. Due to its alkaline nature, it offers higher acid resistance.

Disadvantages:

Lime is highly alkaline and can severely burn skin. If excess of water is used, the slaking proceeds slowly and the resulting paste is thin and watery.

Super Sulphated Cement

Raw Materials:

Ground granulated blast-furnace slag (79–85%), gypsum (10–20%), alkaline additives (1–4%).

Location:

Hyper-arid, arid, semi-arid, sub-humid regions.

Use:

Structural system.

Description:

Super sulphated cement is a binder that can be used to make concrete instead of regular cement. Granulated blast-furnace slag, sulphate agents, and specific additives make up this cement. It is made from granulated blast-furnace slag as the fundamental hydraulic component, with sulphate activators and alkaline additives added to improve the hydraulic qualities. When compared to conventional cements, the production of this type of blast-furnace slag binder does not require any burning, resulting in a CO_2 savings of up to 90%.

The minimal heat development allows for the avoidance of costly cooling procedures for fresh concrete and is up to four times more resistant to dissolving assault than other cements and has a resistance to acid attack (76% higher than concrete built with equivalent Portland cement). Super sulphated cement also has a high sulphate resistance and as a result of this resistance, the concrete does not expand. Additionally, it offers a high final strength as well as a significant reduction in CO_2 and NO_x emissions (Kim et al. 2021). It is suited for use in difficult soils or caustic industrial applications due to its increased compressive strength and stronger acid and sulphate resistance. A typical concrete created with sulphated cement has a heat of hydration of 9 °C, which is 75% lower than standard concrete products. This makes it ideal for applications like dam construction, where thermal expansion during setting must be prevented (Edwards 2011).

Advantages:

Low carbon footprint, low heat development, increased acid resistance, high sulphate resistance and high final strength.

Disadvantages:

Slower strength development, and the resulting curing requirements. Unfortunately, any low-CO_2 successor to Portland cement will initially be an expensive alternative.

6.4 Salt

Salt Blocks

Raw Materials:

Salt (*NaCl*) crystals with a little amount of clay and sand.

Location:

Hyper-arid, arid, semi-arid, sub-humid regions.

Use:

Infill.

Description:

Salt blocks under the name of *karshif*, an unusual material made of *NaCl* salt crystals with impurities of clay and sand, can be found at Siwa oasis in Egypt. The blocks of irregular shape taken from the salt crust that surrounds the salty lake, are cut into smaller blocks and utilised in the masonry with a mud mortar very rich in salt obtained from two different clays, *tafla* or *tiin*. During the drying process of this particular kind of mortar, a strong connection is established between the salt blocks and the mortar due to the crystallisation of NaCl inside the mortar itself, giving rise to a sort of monolithic conglomerate. The traditional mortar which contains 80% silt from the mountains and 20% silt from lakes can be enhanced to become more durable by adding materials such as calcium oxide (*CaO*) and ash or rice husk. These additives are added to the mortar to increase its durability and strength as the traditional mortar components are essentially made from silt which is very weak and not able to resist any source of water (Farouk Mohamed 2020). It is important to underline that *karshif* blocks are directly extracted from the salt crust without any attempt of regularization. Their shape is similar to an irregular 'ball' and they cannot be rectified because of their tendency to break. The technology needed for such building process is very primitive (Rovero et al. 2009).

Advantages:

Salt blocks have a high thermal insulation (Farouk Mohamed 2020).

Disadvantages:

Vulnerable towards the environmental aggressive actions such as water and thermal cycles that can damage the material.

References

AVEI TAEI (2021) Building with earth. UNESCO Chair "Earthen architecture, constructive cultures and sustainable development". https://www.earth-auroville.com/world_techniques_introduction_en.ph. Accessed 24 Sept 2021

Bennett B (2002) Lime plaster and render reinforcement. The Building Conservation Directory

Clough W (1920) Cottage building in cob, pisé, chalk and clay a renaissance, 2nd edn. Country Life, London

Coogee-Chemicals (2014) Sodium silicate safety data sheet.

Coquina—a porous limestone composed almost entirely of fossil debris (2014) https://geology.com/rocks/coquina.shtml.

Davidovits J (2013) Geopolymer cement. A review geopolymer institute, technical papers 21:1–11

Deventer JSJv (2014) Geopolymer and alkali-activated technology. Zeobond Pty Ltd. http://www.zeobond.com/company.html. Accessed Dec 2014

Dillon D (2012) St. Augustine, FL: Coquina—the king's building material. www.dougdillon.com, vol 2014.

Downton P (2013) Your home, Australia's guide to environmentally sustainably homes. Commonwealth of Australia Department of Industry, Science, Energy and Resources

EBUKI (2014) The EBUKI resource library

Edwards P (2011) Future cement—looking beyond OPC

Egenti C, Khatib JM (2016) 13—Sustainability of compressed earth as a construction material. In: Khatib JM (ed) Sustainability of construction materials, 2nd edn. Woodhead Publishing, pp 309–341. https://doi.org/10.1016/B978-0-08-100370-1.00013-5

El-Haggar SM (2007) Chapter 5—Sustainability of municipal solid waste management. In: El-Haggar SM (ed) Sustainable industrial design and waste management. Academic Press, Oxford, pp 149–196. https://doi.org/10.1016/B978-012373623-9/50007-1

Farouk Mohamed A (2020) Comparative study of traditional and modern building techniques in Siwa Oasis, Egypt: Case study: affordable residential building using appropriate building technique. Case Studies in Construction Materials 12. https://doi.org/10.1016/j.cscm.2019.e00311

Fielding R (2012) Review of sustainable building materials and design. Lessons to date and recommendations. Build It International

Geiger O (2011) Kaolinite/kaolin clay. Geopolymer house blog—open source project to develop geopolymer cast stone construction, vol 2014

Haar PW, Kerry & Australia. Aboriginal and Torres Strait Islander Commission (1992) Housing in the torres strait region: towards a self-help approach. Aboriginal and Torres Strait Islander Commission, Canberra

Handreck K (1993) Gardening down-under: better soils and potting mixes for better gardens. CSIRO Publications, East Melbourne, Vic

Herzog T, Krippner R, Lang W (2017) Facade construction manual, 2nd edn. Walter de Gruyter

Khalili N (2014) SuperAdobe: Powerful Simplicity. California Institute of Earth and Architecture (Cal-Earth). https://www.calearth.org/intro-superadobe. Accessed 18 Nov 2014

Kim H-S, Kim I, Yang W-h, Moon S-Y, Lee J-Y (2021) Analyzing the basic properties and environmental footprint reduction effects of highly sulfated calcium silicate cement. Sustainability 13(14):7540

King HM (2014) Coquina - A porous limestone composed almost entirely of fossil debris. https://geology.com/rocks/coquina.shtml.2020

Knab LI, Clifton JR (1988) Mechanical and physical properties of coquina stone from the Castillo de San Marcos National Monument. National Institute of Standards—Research Information Centre, Gaithersburg

Koko S (2014) Down to earth design. http://www.buildnaturally.com/EDucate/Articles/Lime.htm. Accessed 14 Dec 2014

Lazell EW (1915) Hydrated lime; history, manufacture and uses in plaster, mortar, concrete … manual for the architect, engineer, contractor and builder. Jackson-Remlinger printing co., Pittsburgh

Li ZJ, Ding Z, Zhang YS (2004) Development of sustainable cementitious materials. In: Proceedings of the international workshop on sustainable development and concrete technology. Center Transportation Research & Education, Ames

Matus M (2013) Award-winning biomasong grows bricks from sand and bacteria to reduce CO_2 emissions. http://inhabitat.com/award-winning-biomason-grows-bricks-from-sand-and-bacteria-to-reduce-co2-emissions/. Accessed 10 Nov 2014

Mercer B (2010) The gypsum construction handbook. Centennial Edition edn. CGC Inc., Canada

Middleton GF (1982) Earth wall construction. vol Bulletin No. 5. Department of Transport and Construction Experimental Building Station, Australian Government Publishing Service, Canberra

Mohanadoss P, Talaiekhozani A, Rosli M, Mohamad zin R, Abd Majid MZ, Keyvanfar A, Kamyab H (2015) Bioconcrete strength, durability, permeability, recycling and effects on human health: a review. https://doi.org/10.15224/978-1-63248-062-0-28

Mok K (2010) Architect grows brick from bacteria, Sand & Urine. http://www.treehugger.com/green-architecture/architect-grows-brick-from-bacteria-sand-urine.html. Accessed 10 Nov 2014

Newton A (1987) Report to stabilised earth structures PTY. LTD on laboratory test strength studies of a cement stabilised lateritic soil. University of Western Australia, Civil Engineering Department, Perth

Pearson GT (1992) Conservation of clay and chalk buildings, 1st edn. Donhead Publishing, London. How are ceramics used in construction? (2019) AZoBuild. https://www.azobuild.com/article.aspx?ArticleID=8367. Accessed 26 Dec 2020

Pilkington B (2019) How are ceramics used in construction? AZoBuild. https://www.azobuild.com/article.aspx?ArticleID=8367. 26 December 2020

Practical-Action (2021) Mud as a Mortar. The Schumacher Centre for Technology & Development. Accessed 13 June 2021

Rosenlocher H, Halser L (2019) DETAIL Research - Desert Sand for Concrete Production. DETAIL Magazine. DETAIL Business Information GmbH, Munich, Germany

Rovero L, Tonietti U, Fratini F, Rescic S (2009) The salt architecture in Siwa oasis—Egypt (XII–XX centuries). Constr Build Mater 23(7):2492–2503. https://doi.org/10.1016/j.conbuildmat.2009.02.003

Sajkovic A (2014) Stone world|stone industry news on production, use and trends. ASN Natural Stone, Inc. https://www.stoneworld.com/directories/2169-stone-guide/listing/2793-asn-natural-stone-inc. 2014

Schundler (2014) Perilate/silicate composites for high temperature insulation and formed shapes. Schundler Product Guide.

Solas, Kelly M (2014) Cellular glass of foamed glass. In: Trade of Industrial Insulation Phase 2. SOLAS Further Education and Training Authority, Dublin

Srinivasan K, Sivakumar A (2013) Geopolymer binders: a need for future concrete construction. ISRN Polymer Science 2013. https://doi.org/10.1155/2013/509185

Stouter P (2013) See how to make lime plaster.

UPC UPdC (2012) Biological concrete for constructing 'living' building materials with lichens, mosses. Science Daily, Science Daily

vanBaerle (2014) Hygiene and silicates

Wang DL, Chen ML, Tsang DDCW (2020) Chapter 5—green remediation by using low-carbon cement-based stabilization/solidification approaches. In: Hou D (ed) Sustainable remediation of contaminated soil and groundwater. Butterworth-Heinemann, pp 93–118. https://doi.org/10.1016/B978-0-12-817982-6.00005-7

WAVIN WAVIN (2014) Shell beach. Shark Bay World Heritage Discovery and Visitor Centre. http://www.sharkbayvisit.com/pages/shell-beach/. Accessed 4 Dec 2014

Young D (1993) Heritage conservation practical notes—stone masonry in South Australia. Department for Environment and Heritage

Chapter 7
Biotic Materials

Abstract This chapter aims to provide a list of biotic resources found in deserts and drylands that are made up of raw biotic materials or materials generated from living creatures. Material resources are mostly concentrated in hyper-arid, arid, semi-arid, and sub-humid regions typical of drylands and deserts. This overview documents materials in their unprocessed state, as well as their use as building material. Materials are assigned to basic construction applications such as structural system, infill, cladding or skin, insulation or thermal mass, and binding agent for quick reference in their suitability to be utilised as future composite materials.

Keywords Biotic matters · Biomass · Ecological resources · Drylands · Building

© The Author(s), under exclusive license to Springer Nature Switzerland AG 2022 59
D. A. Ottmann, *Ecological Building Materials for Deserts and Drylands*,
SpringerBriefs in Geography, https://doi.org/10.1007/978-3-030-95456-7_7

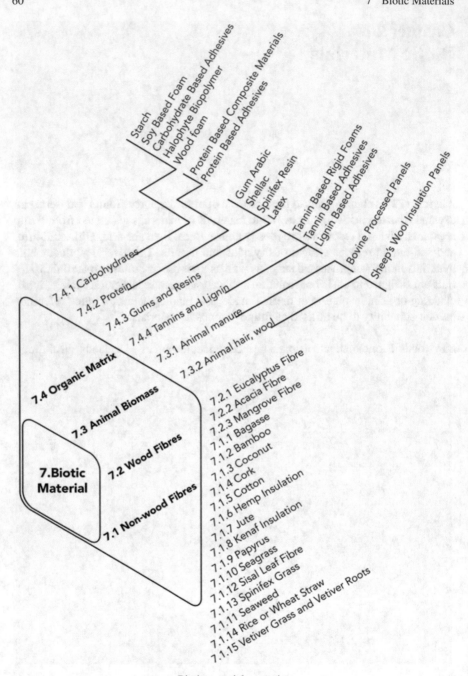

Biotic materials overview

7.1 Non Wood Fibres

7.1.1 Bagasse

Raw Materials:
Sugarcane.

Location:
Arid, semi-arid, sub-humid regions.

Use:
Insulation, cladding.

Description:
Bagasse is the fibrous residue left over after the juice from sugarcane stalks has been extracted. It has traditionally been utilised as a roofing material in traditional Filipino, Jamaican, and Ghanaian homes. Bagasse is one of the world's most renewable resources since sugarcane can be collected up to three times a year. Bagasse is not only 100% renewable, but it is also 100% compostable and biodegradable as a raw material. Bagasse can be used to make long-lasting building materials like polycarbonate and acrylic. These materials are 20 times less fragile than glass, have a low U-value, and are transparent.

Because bagasse may be used to make biomass fuel, its price is rising as demand for alternative fuels grows (Bruehl 2011). Bagasse can be used to replace materials like Styrofoam (foam) and other polymers.

Advantages:
It can withstand heat up to 90 °C as a building and product material. Bagasse has the potential to be used to build structures that will remove carbon dioxide from the atmosphere. Composting time is also considerably shortened with this material.

Disadvantages:
Working conditions in bagasse-producing companies can be poor, with some employees reporting health issues that are supposedly related to the process. Certain building materials, such as polylactic acid generated from bagasse, cannot be completely controlled, which makes their use problematic.

7.1.2 Bamboo

Raw Materials:
Bamboo

Location:
Arid, semi-arid, sub-humid regions.

Use:
 Structural systems, infill, cladding.

Description:
 Bamboo is a grass that belongs to the grass family. When compared to concrete and steel, it has a high compressive and tensile strength. Because it is less expensive than concrete, it is appropriate for low-income groups (Bagchi et al. 2018). The use of bamboo in construction has been practised since the dawn of time. The methods, routines, and apparatuses are usually simple, straightforward, and accessible to even the most unskilled workers. Bamboo-based materials are also commonly used. Bamboo has been used as a structural and non-structural element in its natural state as strong culms, divided culms, or longitudinally split strips.
 Not all bamboo species are suitable for construction. Guadua bamboo (Guadua angustifolia) is suitable for a wide range of constructions and developments due to its exceptional physical properties (Bornoma et al. 2016). Before employing bamboo as a structural material, it is necessary to conduct tests on the specific bamboo species to determine its properties, as bamboo types vary from place to place and hence the attributes of different bamboo vary (Bagchi et al. 2018). Bamboo construction is low-tech and low-cost, making it easier for people to participate in building projects. Bamboo can be weaved or utilised in ancient techniques like mud wall construction (Yuan et al. 2018).

Advantages:
 Bamboo is one of the fastest-growing natural building materials, as well as one of the most accessible and environmentally friendly. It is a cost-effective and easy-to-work-with alternative to steel, concrete, and masonry. Bamboo is light in weight, pliable, and elastic in character, making it ideal for use in earthquake-prone areas. Due to the presence of silicate acid, it has excellent fire resistance.

Disadvantages:
 Because bamboo's shrinkage qualities are inferior to those of wood (bamboo shrinks more than wood), special precautions should be taken when using it in construction to prevent water loss. Bamboo requires covering since it is susceptible to fungus, insects, and other pests.

7.1.3 Coconut

Raw Materials:
 Coconut palm tree, coconut fruit.

Location:
 Hyper-arid, arid, semi-arid, sub-humid regions.

Use:
 Cladding.

Description:

Coconut fibre is a naturally occurring fibre that is derived from the husk of the coconut fruit. Coconut fibres have the potential to be employed in a variety of composites. The outer shell of a coconut is used to obtain coir or coconut fibre. Brown coir fibres are derived from mature coconuts, while white coir fibres are extracted from young coconuts. Brown fibres are thick, robust, and resistant to abrasion. White fibres are finer and smoother, but they are also weaker (Ali 2012). Coconut fibres are also employed in composite products as reinforcement.

The coconut palm's processed stem fibre is known as cocowood (Cocos nucifera). Cocowood not only offers a distinctive building product but it could provide a new income stream for farmers from unproductive older palms that would cover the cost of removing the senile palms and free up land for more productive uses. In a secondary outcome, the soft, nutrient-rich core of the palm's trunk makes an ideal mulch that could be used to improve poor soils and further increase agricultural prospects. Peeled layers of wood can be glued together to make composite flooring products or plywood (Marino 2011). Produce veneer and veneer-based products of various grades from senile coconut stems. Residues from the processes can be used to develop soil conditioning products. Senile coconut stems are widespread and have very low value (Cocowood).

Advantages:

Coconut fibres are moth-proof, resistant to fungi and rot, provide excellent insulation against temperature and sound, are non-combustible, flame-retardant, unaffected by moisture and dampness, tough and durable, resilient, springs back to shape even after constant use, are completely static free, and are simple to clean.

Disadvantages:

The wood of the coconut stem has no natural resistance to attack by wood-boring insects and decay fungi. Freshly cut wood is very susceptible to infection by mould and stain fungi. Coconut wood is also known to be more susceptible to soft-rot decay FOA (1985). Coconut natural fibre decomposes rapidly in an alkaline environment.

7.1.4 Cork

Raw Materials:

Cork oak tree.

Location:

Arid, semi-arid.

Use:

Cladding, flooring, insulation

Description:

Cork is made from the bark of the cork oak (Quercus Suber L.), and it is made entirely of natural plant tissue. It is made up of a honeycomb of microscopic cells

that are filled with an air-like gas and are primarily coated with suberin and lignin. Polysaccharides, ceroids, and tannins are among the chemicals found in their chemical composition, though in less amounts. Each cork oak takes 25 years to reach the point where it can be stripped for the first time, and it is only after the third stripping (at 43 years old) that the cork reaches the excellent grade required for cork stoppers.

The first two harvests, as well as the wood cut from the tree's base, are used to make insulation, flooring, and other items used in industries as diverse as building, fashion, design, health, energy generation, and aerospace. Cork can be utilised to make acoustic and thermal insulation agglomerates that are 100% natural and have high technical performance. It is virtually indestructible and totally recyclable, and it retains all of its qualities throughout the product's useful life. It is manufactured in a factory without the use of additives and uses very little energy. Cork is a lightweight, elastic, and compressible natural, adaptable, and sustainable material. It is impervious to liquids and gases, as well as fire resistant, abrasion resistant, and hypoallergenic (Amorim 2014).

Advantages:
Cork is long-lasting, abrasion resistant, flexible, fire and insect resistant, and waterproof. Cork's manufacturing process produces nearly little waste. It has antibacterial properties, is hypoallergenic, and is completely recyclable.

Disadvantages:
Cork is easily discoloured or damaged. Temperature and humidity fluctuations cause it to expand and contract.

7.1.5 Cotton

Raw Materials:
Cotton (*Gossypium*).

Location:
Arid, semi-arid.

Use:
Insulation

Description:
Cotton is a subtropical plant that can be found in many warm climates throughout the globe. It began as a tropical plant, but it is now grown in other warm climates with at least 200 frost-free days. The United States, China, India, Pakistan, and Australia are the most important cotton-producing countries. Cotton plants can grow to be up to 2 m tall. Cotton seeds are planted in rows by hand or machine after the soil is ploughed in the spring. Flower buds begin to form three weeks after the plants emerge. They have white blossoms that turn crimson and fall off as the season progresses. The blossoms produce a green fruit known as a boll, which contains

seeds. Around the seeds, white fibre of various lengths grows. When the boll bursts open and the fibres inside are visible, cotton can be harvested. The best cloth is made from the longest fibres, which can be up to 6 cm long. The majority of fibres, on the other hand, are significantly smaller. Cotton producers must be vigilant during the growing season to ensure that their crop is disease-free. Insecticides are used to keep insects away from the plant. Every year, these insects damage over 15% of the world's cotton. Cotton plants are also harmed by weeds. They deplete the moisture that plants require. Cotton is harvested 150–200 days after it is planted by farmers. Picking machines drive through the fields in industrial countries, harvesting the cotton and transporting it to a trailer. Cotton harvesting is generally done by hand in the Third World. Cotton fibre is separated from the seeds using gins. After that, the cotton is combed, dried, cleaned, and compressed into bales. Cotton fibre is a soft and staple fibre that forms around the seeds of the cotton plant (Ali 2012). Cotton fibre is made from plants of the genus Gossypium, which belongs to the Malvacae family of plants, and contains practically pure cellulose.

Cottonseed is pressed for oil that is used in salad oils, cosmetics, soap, candles, detergents, and paint, while cottonseed hulls and meal are used for animal feed (Roberts 2014). Several producers use recycled cotton fibres to make thermal and sound insulation materials (Asdrubali et al. 2015).

Using high-frequency hot-pressing, a novel environmentally friendly thermal insulation material called binderless cotton stalk fibreboard (BCSF) was produced from cotton stalk fibres with no chemical additions. The BCSF is especially ideal for ceiling and wall applications because it is an environmentally benign and reusable material. The BCSF is particularly ideal for ceiling and wall applications to save energy because it is an environmentally benign and renewable material (Zhou et al. 2010).

Advantages:
Cotton is a non-toxic and easy-to-handle material. Denim cotton insulation saves landfill space by diverting a byproduct that would otherwise be thrown.

Disadvantages:
Cotton insulation absorbs water and provides a tempting feeding source for pests.

7.1.6 Hemp

Raw Materials:
Hemp fibre.

Location:
Arid, semi arid.

Use:
Insulation

Description:

Hemp is a naturally insulating material that takes 100–120 days to grow to a height of about 4 m. Hemp production does not require chemical protection or hazardous additions because the plants shade the soil. Hemp is carbon-negative because it locks in carbon during its growth, as well as has little embodied energy during manufacturing. Hemp has excellent thermal insulation. It is a porous material that occludes the air, leading to a low thermal conductivity. It provides sufficient acoustic insulation and has a good capacity of hygrometric regulation without the loss of its insulating qualities. It is able to breathe, avoiding the formation of condensations. It adapts perfectly to the irregularities of the frame to guarantee an isolation of quality. It is non-irritating and recyclable and has good mechanical resistance. Since hemp is a natural fibre that does not contain albumen, the risk of being attacked by parasites and rotting does not exist (Cannabric 2014).

To make hemp fire resistant, it can be treated with a non-toxic chemical substance (Black Mountain Insulation Ltd, n.d.). Boron salts can be used to protect the insulation from mould growth. Currently, a considerable proportion of hemp fibres are used for production of insulating materials; however, it is feasible to extend this market not only by increasing the hemp growing and insulation production volumes but also by developing new hemp-based insulation products (Lekavicius et al. 2015).

Advantages:

Hemp is a simple to grow plant that thrives in practically any soil. Hemp also has air-purifying properties, as it eliminates a significant amount of CO_2 from the atmosphere. Hemp is 100% recyclable and causes no irritation to the skin or lungs. It is free of hazardous chemicals and has no odour. It is well insulated both thermally and acoustically. During the manufacturing process, very little energy is consumed. It is a long-lasting, moisture-regulating substance.

Disadvantages:

The insulating properties of hemp can be influenced negatively if placed in a damp environment. However, you can also opt to apply a vapour barrier as a solution.

7.1.7 Jute

Raw Materials:
 Jute (*Tiliaceae*).

Location:
 Arid, semi-arid.

Use:
 Insulation, cladding.

Description:

Jute fibre comes from the Corchorus genus in the *Tiliaceae* family. It is a long, soft, and lustrous vegetable fibre that ranges in colour from off-white to brown. Jute

fibres are known for their high tensile strength and low extensibility (Ali 2012). The fibres are removed from the stem's ribbon. Plants are gathered by cutting them close to the ground using a sickle-shaped knife. The 5 mm small fibres are made by retting in water, pounding, removing the fibre from the core, and drying in that order. A jute fibre is a three-dimensional composite made up primarily of cellulose, hemicelluloses, and lignin, with tiny amounts of protein, extractives, and inorganics (Sen and Reddy 2011).

Jute fibre, a plant-based natural fibre insulation, has the ability to store carbon for the duration of its useful life. Plants retain carbon during their growth, and it stays stored during their use as a building material. It releases carbon either through natural decomposition, returning other nutrients to the soil, or by generating heat energy by being burnt as fuel at the end of its life. In either case, this is a relatively effective end-of-life treatment. During installation, non-toxic jute fibre insulation material can be installed without the use of protective clothes or respirators.

Natural fibre insulation products are also more durable in comparison. Natural fibre insulation off-cuts do not require separate waste streams when utilised on site, and can usually be composted or bio-digested instead of going to landfill (Sutton et al. 1999).

Jute fibres can also be weaved and utilised to make composite materials, such as Jute Fibre-Reinforced Concrete, Jute Fibre-Reinforced Bricks, and Jute Fibre Panels.

Advantages:
Jute is particularly resistant to decay. To improve water resistance, lignocellulosic fibres are preferentially bound with phenolic resin. The fibres have a high tensile strength and a high specific heat-storage capacity. The use of natural insulations with high thermal mass in roofs can be particularly beneficial. Natural fibre insulation has excellent hygroscopic properties.

Disadvantages:
Jute is the weakest stem fibre because of its short fibre length.

7.1.8 Kenaf

Kenaf Insulation Panels

Raw Materials:
Kenaf (*Hibiscus cannabinus*), sometimes combined with hemp fibres.

Location:
Semi-arid.

Use:
Insulation

Description:
Kenaf fibre is very durable and has good mechanical and physical properties, it can be used in very soft panels of various thicknesses for filling cavities and compartments

as a very effective insulator. The panels are produced working the fibre, without any addition of adhesives or chemical elements; they are simply pressed or twisted to form semi-rigid panels that, depending on the thickness, are able to respond well to both mechanical and thermoacoustic stress. Although natural, it does not create problems related to insects, birds or rodents and does not generate rot and it is insensitive to the environmental humidity. This particular aspect, combined with good breathability, makes kenaf fibre very suitable for ceilings and cavities and grant a healthy and comfortable environment (Caiazzo 2013). For the insulation of vented roofs and cavity walls, thermal and acoustic insulation panels produced from a mix of natural hemp and kenaf fibres are used in some circumstances.

Advantages:
 Caiazzo (2013) claims that kenaf fibre is 100% recyclable and provides great insulation and sound absorption. It is rat resistant, non-toxic, hypoallergenic, and manufactured without the use of chemicals or adhesives, and it is simple and quick to apply. Kenaf absorbs CO_2 at a significantly high rate (Ardente et al. 2008).

Disadvantages:
 Thermal conductivity depends on moisture and chemical and physical deterioration of the material (Ardente et al. 2008).

7.1.9 Papyrus

Raw Materials:
 Papyrus

Location:
 Arid, semi-arid, sub-humid.

Use:
 Infill, Cladding.

Description:
 The magnificent emergent macrophyte *Cyperus papyrus L.* (commonly known as papyrus) belongs to the *Cyperaceae* family, reaching 4 m in height and growing along the Nile's banks was utilised amongst others by ancient Egyptians as a flexible writing substrate of vegetable origin (Nicholson and Shaw 2000). Moreover, papyrus stems were packed together to make boats, as well as weaving papyrus fibres into water resistant ropes, mats, baskets, and tables (Lewis 1992).
 Papyrus fibres have also been utilised to strengthen soil. In a unitary coherent matrix, the fibres operate to interlock particles and aggregates. Typically, isolated fibres are simply put into the soil and mixed in, much like cement, lime, or any other addition. The conservation of strength isotropy and the lack of possible failure planes, which might form parallel to the orientated reinforcement are two of the primary advantages of randomly dispersed fibres (Al-Adili et al. 2012). Tests conducted by

Al-Adili et al. (2020) found that papyrus fibre reduces the dry density of the soil due to its low specific gravity and unit weight. The shear stress of fibre-reinforced soil was improved by the addition of 10% papyrus fibres and that 10% addition of papyrus improves the strength of the soil by increasing the elasticity and reducing the displacement.

Advantages:
Papyrus is formed of a highly rot-resistant cellulose and it is biodegradable.

Disadvantages:
Storage in humid conditions can result in moulds attacking (Adams 2015).

7.1.10 Seagrass

Raw Materials:
Seagrass (*Posidonia oceanica*).

Location:
Submarine environments in arid, semi-arid, sub-humid areas.

Use:
Insulation, cladding.

Description:
Thermal insulation can be made out of natural fibrous balls that derive from seagrass (*Posidonia oceanica*) also known as *Neptune Balls* or *Neptune Grass*. The sea balls are carefully collected, dried and tested. When approved for use, the fibres have the ability to absorb humidity from the environment, buffer it, and give it back without any influence on thermal insulation (Hebel et al. 2014).

This new material is primarily used for thermal and acoustic insulation and may be introduced into the internal cavities within a building, roof, façade, wall, floor and ceiling. The natural material used to make these Neptune balls is considered a waste product and is commonly disposed of in landfills. However, it has several properties that make it appealing to the construction industry: seaweeds are practically non-flammable, mould-resistant, and insulating material without chemical additives. It may be used to insulate internal walls, insulate pitched roof rafters, and minimise the amount of heat lost through building envelopes. Fibres function as a buffer, collecting and releasing water vapour without affecting the body's capacity to remain cool. Fibres function as a buffer, collecting and releasing water vapour without compromising the building's capacity to keep it insulated. Neptune balls, which have a salt concentration of only 0.5–2%, can be utilised to make non-rotting insulating material. In hot weather, the fibrous material keeps buildings cool by hiding them from the sun. The insulation itself is not difficult to install, and while it is usually done by specialists, it may also be done by untrained individuals.

The fibrous material may be packed tightly into the hollow areas of roof structures, walls, and ceilings by hand. Gräbe (2013) recommends using a machine to blast insulation into hard-to-reach areas. Rectangular panels using *Posidonia oceanica* and 100% bio-based bonding materials can also be made and used as cladding.

Advantages:

Posidonia fibres are an alternative to insulation materials produced from crude oil products. When compared with other natural fibres, seagrass is in a unique position as it is not produced by agricultural or forestry processes and is therefore not in competition for land space with food production. Furthermore, it is suitable for both thermal and acoustic insulation and is inherently non-inflammable and resistant to mould, making additional treatment with chemicals unnecessary (Baden-Württemberg 2007–2013).

Disadvantages:

Sand that has stuck to the Neptune balls is difficult to remove. Furthermore, individual fibres are easily caught on everything, even one another, and create new clumps quickly, both during processing and afterwards when blown into places that require insulation.

7.1.11 Seaweed

Raw Materials:
 Eelgrass

Location:
 Submarine environments in coastal arid, semi-arid, sub-humid areas.

Use:
 Insulation, cladding.

Description:

According to Søndermark (2013), Seaweed-clad houses were once a common traditional construction method on the island of Læsø. Seaweed reproduces itself every year in the sea, washes up on shore without human intervention, and is dried by the sun and wind on surrounding fields. It insulates as effectively as mineral insulation, is non-toxic and fireproof, and has a life expectancy of over 150 years.

Seaweed can be enclosed in wooden cases to use as insulation behind the facade and beneath the floors or as cladding rolled into netted bags and attached it in lengths across timber-framed walls and roof of the house (e.g. the recent Vand-kunsten seaweed house). Eelgrass panels have also been investigated as a set of prefabricated eelgrass-thatched panels to suit roofs or facades (Aouf 2019).

Advantages:

Seaweed has remarkable acoustic properties as well as the ability to absorb and emit moisture (Hebel et al. 2014). Good insulating qualities are comparable to that of

mineral insulation, in addition to being non-toxic and fireproof. Seaweed also has a long shelf life, is inherently resistant to vermin and putrefaction, and comes in large quantities (Byg 2013).

Disadvantages:

Environmental risks associated with large-scale seaweed cultivation (e.g. release of reproductive altered genetic materials, disease and parasites) (Campbell et al. 2019).

7.1.12 Sisal Leaf

Raw Materials:
Sisal (*Agave sisalana*).

Location:
Arid, semi-arid, sub-humid.

Use:
Insulation

Description:
Sisal fibres come from an agave plant and are stiff. These fibres are golden in colour and are straight and silky. Sisal fibres are known for their strength, resilience, and ability to stretch (Ali 2012). The plants resemble enormous pineapples, and the leaves are chopped as near to the ground as possible during harvest. By hand or machine, the soft tissue is scraped from the fibres. The fibres are dried, and the residual dirt is removed using brushes, resulting in a clean fibre. Sisal fibres are durable and robust. Sisal fibre is one of the potential reinforcing materials, although its application has so far been more experiential than technical.

Sisal fibre is mostly made up of cellulose, lignin, and hemicelluloses. It is utilised as a cement reinforcement, and sisal fibres are employed as housing reinforcement in underdeveloped nations (Sen and Reddy 2011). Sisal fibres have been successfully utilised to make gypsum plaster sheets in Australia.

Advantages:
They have excellent moisture resistance. These fibres have a high tensile strength and resilience to tension. They have excellent heat resistance. Sisal short fibres prevent early fracture formation by delaying controlled plastic shrinkage. Sisal fibres that were conditioned in a sodium hydroxide solution preserved 72.7 and 60.9% of their original strength, respectively.

Disadvantages:
Sisal fibres are susceptible to breakdown in alkaline conditions or when exposed to biological assault.

7.1.13 Spinifex Grass

Raw Material:
 Spinifex Grass (*Triodia*)

Location:
 Semi-arid regions.

Use:
 Insulation, cladding.

Description:
 Triodia are the dominant plant species of more than a quarter of Australia's land mass and are also significant subdominant species in northern regions. Spinifex was traditionally used to construct shelters (Geoff 2012). Both fibres and resin have potential uses in building technology as either separate or combined) (composite products. *Triodia*-derived fibres and resin are being explored for potential uses in the building industry such as insulation batts, biodegradable plastics and polymer products. Spinifex resins are considered to be bio-organic polymers which belong to the thermoplastic class of biopolymer. Within a low-tech to high-tech spectrum of possible applications, a variety of products are being researched ranging from shade roofs, evaporative cooling walls, spinifex reinforced-earth walls and slabs, spinifex insulation batts (all at the low-tech end), to nano-whisker paper, resin to replace urea formaldehyde, coatings that may have anti-termite and ultra-violet screening capacities as well as bio-composite materials comprising fibre and resin (at the high-tech end) (Gamage et al. 2012). Plant fibres such as kenaf, flax, jute, hemp, sisal, coir and ramie are widely used for reinforcement of thermoplastic and thermosetting matrices in order to enhance mechanical and other functional properties; stem and leaf fibres of the stiff non-resinous species of *Triodia* could potentially be used in a similar pattern (Gamage et al. 2012).

Advantages:
 Spinifex nano-fibres are natural, abundant, biodegradable, light and strong. Isolating nanofibre from spinifex grass needs minimal chemicals and energy compared to other sources such as wood and cotton (Amiralian 2018).

Disadvantages:
 More research is required to define durability, ignition behaviour, and resistance to moisture and biological attack.

7.1.14 Straw (Rice or Wheat)

Raw Material:
 Rice, wheat straw.

Location:
 Arid, semi-arid, sub-humid regions.

Use:
 Structural system, insulation, cladding.

Description:
 Straw bales can be used either as load-bearing structure or as infill wall. There are different techniques used in construction for the infill wall system including post and beam structures, and more commonly practiced, beam structures and frame (truss) with straw infill (Dikmen and Ozkan 2015).

 Building panels that take discarded harvest residues, such as rice or wheat straw, as their raw material resource can also be compressed without any additions into various panel sizes and shapes. Adhered with waterproof papers, they are cut to length and immediately placed into a light steel wall-frame system. Equipped with this edge protection they can be used as an interior or exterior building element. The boards are usually waterproofed with a moisture barrier and covered with any conventional outdoor surfacing material, including stucco, vinyl, shingles, or stone (Hebel et al. 2014).

Advantages:
 Straw is an excellent acoustic insulator, the material reduces noise by 65 decibels per panel (Hebel et al. 2014). The potential of recycling rice residue is significant for crop production systems (Dikmen and Ozkan 2015). Straw bales are 100% biodegradable. Straw bale construction techniques can be easily undertaken by unskilled labourers.

Disadvantages:
 Straw bale walls need to be kept dry as moisture and mould are significant risks, as well as fire.

7.1.15 *Vetiver Grass and Vetiver Root*

Raw Material:
 Vetiver grass (*Chrysopogon zizanioides*), vetiver roots (*Vetiveria zizanoides*).

Location:
 Semi-arid.

Use:
 Infill, cladding.

Description:
 For centuries, people in rural Asia and Africa have used vetiver culms and leaves for roof thatching. The culms and leaves of vetiver grass are wax-coated and have a distinctive smell that repels insect and fungal assaults, making it a superior choice for roof thatching. In Senegal, vetiver is used to make mud bricks because it prevents breaking (Nanakorn and Chomchalow 2006).

The Royal Project Foundation (Thailand) was successful in making board and veneer from vetiver root mass to substitute wood. The fabrication of these boards was done by mixing vetiver with adhesives—urea formaldehyde, polyvinyl acetate, and corn starch—and keeping them in appropriate formwork (Nanakorn and Chomchalow 2006).

Densified building bricks can be made from vetiver roots in a size of 400 × 200 × 200 mm. They are compacted in a hand-operated press to a density of about 225 kg/m^3. Due to the rough surface resulting from the compacting of the natural fibres, the product can easily be plastered or treated with any other finishing material (Hebel et al. 2014).

Straw bales used in building construction can be made using vetiver leaves. The bales are almost free from insects as the vetiver possesses repelling chemicals in it (Nanakorn and Chomchalow 2006).

Advantages:
Vetiver roots are naturally insect and fungi-resistant and widely available.

Disadvantages:
Labour-intensive to plant, maintain until established and to obtain material (Mason 1996).

7.2 Wood Fibres

7.2.1 Eucalyptus Fibres

Raw Material:
Eucalyptus fibres

Location:
Arid, semi-arid.

Use:
Structural systems, cladding.

Description:
Eucalyptus wood fibres can provide air-cured, wood pulp fibre-reinforced cement composites as an alternative reinforcement to asbestos fibres, producing higher values of fracture toughness (Coutts 1987). The fibres are derived from waste *eucalyptus grandis* pulp (Savastano et al. 2000) incorporation of fly ash and other by-products as beneficial materials in fibre-reinforced composites serves a dual purpose. First, it facilitates achieving the strain-hardening condition, and second, it provides an excellent outlet for industrial by-products (Kayali 2016).

Reinforcing mortars and concrete with *eucalyptus globulus* bark fibres emerges as an eco-friendly building alternative to reuse this industrial waste with the aim of

reducing shrinkage cracking, rapid cracks propagation, and brittle failures (Mansilla et al. 2020).

Advantages:
Natural fibres in concrete can reduce concrete strength significantly and is a suitable option to deal with the issues connected with the usage and disposal of eucalyptus globulus fibre waste (Mansilla et al. 2020).

Disadvantages:
Eucalyptus wood extensively expands and contracts is less durable (than teak wood), and can be susceptible to pests.

7.2.2 Acacia Fibres

Raw Material:
Acacia tortilis.

Location:
Arid, semi-arid.

Use:
Cladding.

Description:
Acacia tortilis bast fibres have the potential to reinforce composite materials that can be used for applications requiring lightweight design combined with higher strengths.

The eco-friendliness and availability of green fibre-reinforced-based composites is attractive as a potential replacement for non-biodegradable synthetic fibre. Green composites are biodegradable and less susceptible to health hazards during the utilization for engineering applications. Furthermore, natural fibres tend for application of lightweight engineering products and provide satisfactory mechanical properties that pose challenges on massive application of green fibres as reinforcement in composite structures.

The content of cellulose positively affects the tensile properties of *Acacia tortilis* fibres but higher amount of lignin reduces the expected fibre strength. The capsule-like structure on the fibre surface increases surface roughness and is expected to assist adhesion during composite making (Dawit et al. 2019).

Advantages:
A replacement for non-biodegradable synthetic fibre as well as being biodegradable and less susceptible to health hazards.

Disadvantages:
Lignin content residing in *Acacia tortilis* fibres negatively affected the tensile strength that leads to the weak strength of *Acacia tortilis* fibre.

7.2.3 Mangrove Fibres

Raw Material:
 Mangrove wood

Location:
 Arid, semi-arid, sub-humid.

Use:
 Cladding.

Description:
 Natural fibres are now fast evolving as potential alternatives to inorganic or synthetic materials for various applications as building materials. There is also the need to reduce the use of petroleum-based materials and use environmentally friendly sustainable materials. Mangroves have evolved a suite of adaptations to cope with extreme environmental conditions that include high salinity, strong winds, tidal variations, high temperature and anaerobic tidal swamps.

 The stem of mangrove wood used as raw material is processed by chipping and crushing into wood particles which are used to reinforce composite materials. The hydrophilicity of mangrove fibres can be improved by heat treatment which removes hemicellulose, lignin, pectin, waxy substances and impurities from the outer surface of the mangrove cell wall. Heat-treated composites show better tensile properties compared to the untreated ones (Adebayo et al. 2019).

Advantages:
 Natural fibres pose some economic advantages compared to synthetic fibres due to their abundance, biodegradability, recyclability and lower cost.

Disadvantages:
 Natural fibres have the disadvantage of incompatibility between the hydrophilic fibres and the hydrophobic plastic matrix, hence there is poor adhesion and poor ability to transfer stress from the matrix to the fibre, thereby reducing mechanical strength and ductility. Need increase in the compatibility and adhesion between fibres and matrices.

7.3 Animal Biomass

7.3.1 Animal Manure

Bovine Processed Panels

Raw Materials:
 Old, corrugated cardboard, bovine processed fibres, and other agricultural fibres.

Location:
Hyper-arid, arid, semi-arid, sub-humid regions.

Use:
Cladding.

Description:
The bio-based panels are produced by combining numerous cellulose sources, wheat straw, hemp, jute, waste wood and more. Their composition can also include cow manure, bovine processed fibre (left over after anaerobic digestion tanks harvest methane from cow manure) and post-consumer waste (Ozler 2011). The production uses for example a wet process that requires no binders or additives but only the hydrogen bond of cellulose fibres under extreme heat and pressure similar to paper-making. The resulting construction panels are lightweight yet resistant. Available in flat sheets, a corrugated wave pattern or a honeycomb shape, they can be used to create furniture, displays, signs and a wide variety of other architectural elements. In some cases, the composite panels are constructed using an eco-burlap and white PVA glue, combined with pressure and heat. They are formaldehyde-free, non-toxic with zero off-gassing (NET 2021). In other cases, the manure fibres from the farms' digesters still have a lot of water, so the fibres are dried, they are then blended with a 15% liquid UF resin and are then pressed and formed into panels (Caldwell 2008). Panels can be clear coated and used in their natural form or treated with standard paints, sealers and decorative coatings (NET 2021).

Advantages:
Free of formaldehyde, chemicals, petroleum and toxic additives. They are non-toxic, recycled and recyclable.

Disadvantages:
No disadvantages noted.

7.3.2 Animal Hair, Wool

Sheep's Wool Insulation Panels

Raw Materials:
Sheep's wool (90%), natural fibres (10%).

Location:
Hyper-arid, arid, semi-arid, sub-humid regions.

Use:
Insulation.

Description:
Sheep have been able to adapt to even the harshest of conditions for thousands of years because their wool protects them through hot, cold, damp, and dry seasons.

Wool has been utilised both for its protective properties and for the numerous other advantages it provides. When wool fibres are pressed together, they produce numerous tiny air pockets due to their crimped structure, which traps air and keeps warmth in during the winter and out during the summer. Wool's one-of-a-kind feature is its ability to breathe. That is, it has the capacity to collect and release moisture from the air without sacrificing thermal efficiency. When wool fibres absorb moisture, they produce a substance called lanolin. Wool fibres create a little amount of heat as they absorb moisture. By keeping the temperature above the dew point in moist situations, this warmth prevents condensation in building cavities. This characteristic produces a natural buffering effect, allowing heat fluctuations caused by relative humidity to be stabilised. In practice, this eliminates the need to constantly change heating and cooling settings since wool insulation keeps a building colder during the day and warmer at night. Crimped wool fibres also provide a high level of durability to the finished product. This means that wool insulation will maintain its thickness, which is one of the most important factors in insulation performance.

Wool is fire resistant because it contains moisture and self-extinguishes when the source of flame is removed. It is also a great airborne and structure-borne acoustic insulation, lowering noise levels substantially throughout a building. Sheep Wool Insulation uses less than 15% of the energy that glass fibre insulation does since it is created from a naturally occurring fibre. Indoor air contaminants such as formaldehyde, nitrogen dioxide, and sulphur dioxide can be absorbed and broken down by it.

Wool is a sustainable and renewable material that has no ozone depletion potential and may be remanufactured or biodegraded at the end of its useful life (Insulation 2014). Sheep's wool is a hygroscopic fibre, meaning it can collect, retain, and release moisture more efficiently than most other materials. It can absorb more than 35% of its own weight in moisture without losing thermal performance, whereas man-made mineral fibre insulation loses thermal performance when condensation is present. Because it has a natural synergy with wood, sheep's wool insulation is suitable for timber frame buildings.

This consistency illustrates sheep's wool insulation's adaptability and capacity to survive in a variety of conditions and humidity levels. Unlike other alternatives, sheep wool insulation is resistant to compaction, which can limit heat conductivity over time. Insulation panels made from sheep's wool and other natural fibres can be treated with borate to prevent bugs, fire, and mould (Energy-Saver 2012).

Advantages:

Sheep's wool is fire resistant and biodegradable; it may be composted in the ground to improve the soil. Sheep's wool insulation may be recycled or burnt to create extra energy.

Disadvantages:

Untreated sheep's wool attracts moths and other insects; therefore, it must be treated.

Animal Hair Plaster

Raw Materials:
 Animal hair, lime, aggregate, water.

Location:
 Hyper-arid, arid, semi-arid, sub-humid regions.

Use:
 Cladding.

Description:
 Lath and plaster were the most popular form of plaster treatment used in both residential and commercial areas until the turn of the century era. The plaster is made up of three ingredients: lime, aggregate, water, and animal hair, which are combined just before being applied on the lath. For instance, horsehair plaster is a reasonably easy combination to make and apply.

 Lime plaster differs from current gypsum plaster in that it cures rather than sets, meaning it collects air carbon and carbonates whereas modern gypsum sets chemically. This distinction manifests itself in terms of time and tending, with lime-based plaster requiring greater cure and tending time. The animal hair fibres act as a bridging agent, regulating the plaster's shrinkage and assisting in the holding together of the plaster's ingredients, which were critical to the plaster's performance and lifespan. Other animal hair was commonly utilised in plaster mixes, but the long hair found on horses' tails makes for the ideal plaster mix.

 The plaster mix could be used on both walls and ceilings, and despite its lengthy application procedure, it dried faster than other frequently used plaster combinations (Earth Daub, Adobe), making it more flexible (Canning 2021).

Advantages:
 Lime hair plaster is exceptionally long-lasting; examples of Egyptian and Roman installations may be found on a variety of structures across Europe and North Africa. It can endure prolonged water intrusion, harsh weather conditions, and is more flexible than gypsum-based materials due to the nature of the substance.

Disadvantages:
 The process is relatively time-consuming.

7.3.3 Carbohydrates

Soy-Based Foam

Raw Material:
 Soybeans

Location:
 Arid, semi-arid.

Use:
Insulation

Description:
Polyurethane (PU) foam fabricated using soy-based polyol can potentially replace conventional petroleum-based PU foam for thermal applications. Soy-based PU foam samples are fabricated by mixing varying amounts of blowing agent and catalyst, and a fixed amount of polyol and surfactant (Dhaliwal 2018).

The following two types of soy-based insulation are available: The closed-cell kind has a frothy texture and is thick and stiff. It is sturdy enough to walk on, and it will help the building withstand heavy winds. It is a good insulator with an R-value of 5.5, but it is more expensive than open-cell. Closed-cell insulation features a vapour barrier, which means it will block or slow the entry of moisture into the attic through the roof, such as rainwater.

Open-cell has a texture akin to broken bubbles and is soft, flexible, and lightweight. Open-cell insulation is less insulating than closed-cell insulation, but it is also less costly, with an R-value of 3.6. It has an air barrier but no vapour barrier, therefore it is best avoided in outdoor applications or places where it could become wet. Soy-based insulation is applied with a water spray, and it swells to about 100 times its original volume, pushing itself into surrounding gaps and crevices as it hardens (Gromicko 2021).

Advantages:
Because it does not include formaldehyde or urea, it is safer than most traditional insulation. Soy-based insulation emits no chemical by-products and is applied with a water spray that is free of hydrofluorocarbons and other hazardous substances. Soybeans, which are a renewable resource, are used in portion of the product. It has a good fire rating and R-value and provides a strong sound barrier. It will not deteriorate or settle.

Disadvantages:
Moisture will cause open-cell insulation to lose most of its effectiveness, and potentially encourage the growth of mould.

Carbohydrate Based Adhesives

Raw Material:
Starch, sucrose blend.

Location:
Arid, semi-arid, sub-humid regions.

Use:
Adhesive.

Description:
Starch is a polymer found in plant seeds, roots, and leaves (Hemmilä et al. 2017). It is a natural polymer that comes in big quantities and at reasonable, consistent pricing. It is made up of glucose units that have been chemically linked together to form a

nonreducing polyhydroxy substance. Starch has a strong affinity for polar molecules like water and cellulose due to its numerous hydroxyl groups. Amylase enzymes or acid hydrolysis can break down starch into low molecular weight carbohydrates (Kruger and Lacourse 1990). Corn starch, sorghum starch, potato starch, tapioca starch, wheat starch, rice starch, and sago starch are all starches that can be used in adhesives. Several tests on natural adhesives based on carbohydrates found starch as a relatively inexpensive and renewable product from abundant plants, which is easy to process and has been widely used in binders, glues and pastes. Still, its bonding capacity is not strong enough to glue wood (Gadhave et al. 2017).

Starch has a wide range of sticky characteristics depending on where it comes from. Because of the significant amount of intramolecular and intermolecular hydrogen bonding, starch is not soluble in water and rapidly precipitates. When used for veneer glueing in plywood manufacture, starch adhesives tend to crystallise upon drying, resulting in reduced contact area and loss of adhesion. The characteristics of starch adhesives are improved via crosslinking and grafting. Isocyanates can be used to crosslink starch to improve plywood's wet and dry bonding strength. Epoxy resin is another universal synthetic adhesive/crosslinker that can be used to crosslink starch and other bio-based adhesives. In both dry and humid circumstances, epoxy groups create three-dimensional networks that provide good shear strength. Latex has also been discovered to improve the moisture resistance of starch and to prevent microbiological growth on the adhesive. Starch-based adhesives have been explored with additional ingredients such as nanoparticles and nanoclays. Because of their tiny size, high surface energy, and unsaturated chemical bonding on the surface, silica nanoparticles and nanoclays have been found to improve the characteristics of polymer materials (Hemmilä et al. 2017).

Advantages:

For the solid wood and plywood sectors, starch-based adhesives offer numerous benefits, including ease of use, cheap cost, and minimal formaldehyde emissions.

Disadvantages:

Starch-based adhesives are difficult to use in industrial board applications due to their lack of reactivity, bonding strength, storage stability, and water tolerance. To achieve the requisite bonding strength, proper modification and crosslinking are required. There are currently no commercially effective bio-based crosslinkers, therefore starch adhesives rely on synthetic crosslinkers such isocyanates and epoxides (Hemmilä et al. 2017).

Haloyphyte Biopolymers

Raw Material:

Halophytes (plants growing in saline conditions).

Location:

Arid, semi-arid.

Use:

Cladding, insulation, biocomposites with halophyte biomass using polymers (PP) and biopolymers (PLA) (Batog et al. 2021).

Description:

Halophytes are plants that can complete their life cycle in extremely salty environments (Yensen 2008). The biomass of tall fescue and hemp of halophyte species from salty areas proved to be a good source of second-generation bioethanol and a natural filler for polymer composites made of standard polymers (polypropylene) and biodegradable polymers (polylactide) (Batog et al. 2021).

Advantages:

Because they grow naturally in saline habitats, primarily in semi-arid and arid places, halophytes do not compete with conventional crops for arable land and freshwater resources. Using halophytes for biofuel production could be a cost-effective and environmentally friendly method for producing bioenergy in the medium future, while also contributing to the revaluation of saline areas that have been regarded unproductive for a long time.

Disadvantages:

Halophytes for bioenergy and polymers need to be grown on a large-scale bearing environmental risks (Debez et al. 2017).

Wood Foam

Raw Material:
 Wood fibres, water

Location:
 Arid, semi-arid, sub-humid regions.

Use:
 Insulation

Description:

Wood foams are light wood-based materials with an open-pore texture manufactured of finely ground wood (40–280 kg/m^3). They derive their strength from the wood's inherent binding properties and hence do not require the use of synthetic adhesives. This means that the foams are entirely made of renewable resources. Wood fibres and water are mashed together to make a suspension, which is subsequently foamed. Both deciduous and coniferous wood can be used as the starting material. Because the wood is finely crushed, it can also be utilised as a raw material for forest thinning and sawmill by-products; non-wood-containing lignocelluloses, such as hemp or straw, can also be employed. The foam's strength is derived from the wood's inherent binding properties, thus no synthetic adhesives are required. As a result, adhesive emissions are unlikely to create any health problems. They can be used for a wide range of purposes, including packaging, lightweight boards, and insulating material (WKI 2020).

Advantages:

Foam wood is a natural substance that can be used instead of synthetic polymeric foams. Wastepaper recycling is an easy and environmentally beneficial way to dispose of wood foam. It is easy to work with, has no odour, and when produced without binders, it has no additives, thus there are no health issues (WBPI 2018).

Disadvantages:

Water absorption can be problematic because it can encourage fungal attacks. A possible solution to this is to add mineral binders to the fibre mix.

7.3.4 Protein

Protein-Based Composite Materials

Raw Material:

Casein (PLA from Milk)

Location:

Hyper-arid, arid, semi-arid, sub-humid regions.

Use:

Cladding.

Description:

Natural structural proteins have evolved over millions of years to provide crucial structural and functional capabilities. Blending (mixing) proteins is a method of producing protein-based biomaterials with a wider range of specialised features. Many natural proteins have been examined, with mechanical, chemical, electrical, electromagnetic, and optical properties that may be distinguished. Some of the most frequent structural proteins explored for protein-based biomaterials are elastins, collagens, silks, keratins, and resilins.

Protein-based composite biomaterials can be made into a variety of tuneable biomaterials, including those that govern cell responses. The capacity to adjust or tune mechanical, surface and regeneration properties is a significant step forwards for biomaterials in general, allowing them to serve a wider range of medical material and device applications. Because of their inherent biocompatibility, biodegradability, and natural abundance, as well as their unique natural characteristics, these composites have shown promise in producing the next generation of functionalized biomaterials (e.g. mechanical, optical, electrical, chemical, thermal (Hu et al. 2012).

Casein is a biopolymer present in milk that can be extracted by acid precipitation. Casein has two separate applications in the building industry: paints and self-levelling underlayments. To obtain a levelled layer of paint, paints require additives that not only viscosify but also give self-levelling qualities. Both qualities are provided by caseinates, which are made by neutralising casein with alkali hydroxides. Self-levelling underlayments with casein have outstanding self-healing qualities. The scar will close and regenerate a completely even surface after being cut with a knife (Plank 2005).

Advantages:

In addition to their viscosity, caseinates feature self-levelling and self-healing capabilities.

Disadvantages:
Caseinates biodegrade quickly.

Protein-Based Adhesives

Raw Material:
Proteins (soy, palm, canola, cottonseed, sunflower, casein (PLA from Milk), animal blood and feather).

Location:
Arid, semi-arid, sub-humid.

Use:
Adhesive.

Description:
Mechanical or solvent extraction of oils is the most prevalent source of proteins, with soy, palm, canola, cottonseed, and sunflower oils accounting for the largest markets. Additional protein sources include zein from maize seeds, casein from milk, as well as animal blood and feathers. Denaturation of a protein is required to expose additional polar groups for solubility and hydrogen bonding. Denaturation is a term that refers to a process that alters the secondary, tertiary, or quaternary structure of a protein molecule without disrupting its covalent bonds. This procedure unravels the protein and exposes its hydrophilic groups for modification. Heat, acid/alkali, organic solvents, detergents, or urea can all denature proteins. Proteins derived from a variety of sources react uniquely to changes and additions. For example, in a study by Cheng et al. (2016), it was discovered that modifiers having an anionic charge (e.g. glutamic acid, acetic acid, butyric acid) benefit cotton seed protein adhesive, however, no good effect was observed in soy protein adhesive formulations. Similarly, it has been demonstrated that the adhesive capabilities and water resistance of soy protein isolates are much superior to those of wheat gluten protein following alkaline treatment. Pradyawong et al. (2017) reported the development of lignin-modified soy protein adhesives with enhanced mechanical and water resistance capabilities. Additionally, the use of a waterborne polyurethane based on soy oil improves the water resistance of soy adhesives. Polyamides are the most often utilised crosslinking agents in soy protein adhesives. However, because of the low solid content and high viscosity of polyamides, different curing agents have been investigated in the literature (Hemmilä et al. 2017).

Advantages:
Proteins are abundant, environmentally safe, and generally easy to handle. They also have low pressing temperatures, which results in lower manufacturing costs, as well as a high viscosity.

Disadvantages:
Proteins have low water resistance (mostly) and denaturation is required.

7.3.5 *Gums and Resins*

Gum Arabic

Raw Material:
 Acacia Senegal Tree.

Location:
 Arid, semi-arid.

Use:
 Binding agent.

Description:
 True gums are created when internal plant tissues disintegrate, primarily by the degradation of cellulose in a process termed gummosis. Gums are abundant in sugar and are closely related to pectins. They are colloidal and soluble in water, either completely dissolving or swelling, but not in alcohol or ether. They naturally exude from the stems or in response to the plant being wounded. Commercial gums are derived from dried exudations. Gums are particularly prevalent in plants that grow in dry environments. They are mostly employed as adhesives, but they are also used in textile printing and finishing, as a paper sizing agent, in the paint and candy industries, and as medications (Legner 2021). Gum Arabic (Acacia species) is a dried exudate from species of the acacia tree. Most of the commercially available gum comes from a single species called *Acacia Senegal*. Gum Arabic is a complex mixture of calcium, magnesium and potassium salts of Arabic acid and is produced by bacteria on wounded surfaces of acacia trees. In paints and similar formulation flocculation, gum Arabic is used as a binder where it prevents hard setting of pigments. Gum Arabic is also used as an admixture to concrete with the dual function of setting accelerator and normal water reducer (Ahmed and Abdullatief 2018). The extraordinary adhesive properties of gum Arabic may be advantageous in the construction of plasterboard, where starch is now employed to bond the cardboard to the gypsum core (Plank 2005).

Advantages:
 Gum Arabic is a natural organic viscous sealant material and a water-soluble solid substance.

Disadvantages:
 Tapping is the artificial wounding of stems and branches of trees for the production of gum Arabic through shaving off the bark using sharp instruments. The number of wounds per tree should be limited. Too much wounding will result in smaller or dusty tears, which are generally regarded as inferior quality, damage the tree health and affects sustainability of gum Arabic production. Difficulty in guaranteeing consistent quality.

In some countries that produce gum Arabic, such as Ethiopia, there is a lack of infrastructure to source the gum. Deforestation, overgrazing, resettlement and human induce fire are other threats that affect the use of gum Arabic (Tadese et al. 2018).

Shellac

Raw Material:
 Stick-lac Insect (*Tachardia lacca*).

Location:
 Arid, semi-arid.

Use:
 Binding agent, finish.

Description:
 Resins are chemical compounds that arise as oxidation products of various essential oils and have a very complex and variable chemical composition. Typically, resin is secreted into defined cavities or passageways. It frequently seeps through the bark and hardens upon contact with air. Generally, tapping is required to obtain a sufficient quantity to be commercially valuable. Additionally, commercial resins are frequently extracted from fossilised materials. Resinous substances can be found on their own or in conjunction with essential oils or gums. In contrast to gums, resins are insoluble in water but soluble in ether, alcohol, and other solvents. While resin manufacturing occurs naturally, only a few families are commercially significant. True shellac is not a direct plant product; it is manufactured from stick-lac, a resinous substance released by an insect called *Tachardia lacca* on the twigs of numerous trees. The lack bug feeds on tree sap and secretes resin to defend itself and its progeny. Stick-lac crude is extracted from twigs and steeped in water to produce a red colour. After drying, it is powdered to a granular consistency. This seed-lac is melted and then dried in thin sheets. These are then separated into the semitransparent, brittle, orange-red flakes that comprise shellac. When poured out in droplets, melting seed-lac hardens into the thick spherical pieces known as button-lac. Frequently, shellac is bleached. At one time, shellac had a wide variety of industrial applications, but synthetic replacements derived from petroleum have mostly displaced it. True shellac is easily moulded. It is a superior insulator that was previously widely utilised in the electrical sector. It was the primary spirit-varnish resin, producing a durable film with a smooth finish and the ability to polish to a high sheen. Shellac is a natural resin that can be used to make sealing wax or nitrocellulose lacquers (Legner 2021).

Advantages:
 Shellac is a naturally occurring bioadhesive polymer that is chemically equivalent to manufactured polymers and so a natural type of plastic. It is easy to work with and has natural insulating characteristics.

Disadvantages:
 Because shellac varnishes are not water resistant, they cannot be utilised out.

Spinifex Resin

Raw Material:
 Spinifex Grass -*Triodia* (Soft Species).

Location:
 Arid, semi-arid.

Use:
 Binding agent.

Description:
 Spinifex species are typically classified into two informal groups based on their growth forms, ranges, and physiology. The 'hard' species have tightly packed, rigid leaves that are nearly impossible to touch, whereas the 'soft' species have somewhat loosely distributed, less rigid leaves that can be handled more easily. The primary and most widely used method of resin processing involves threshing soft spinifex plants to remove the adhering resin. Spinifex resin is a thermoplastic substance, which means that it is hard and brittle below its glass transition point—roughly 25 °C—and soft and flexible above that temperature, making it a perfect adhesive (Pitman and Wallis 2012).
 Because of its waterproofing properties, spinifex resin is also an effective sealer, unlike gum adhesives. Spinifex resin was also commonly used to fill minor holes and fix cracks in wood and other materials. Spinifex resin is most commonly used as a glue to connect materials together to produce composite objects (Pitman and Wallis 2012). Spinifex resin can be modified mechanically by adding extra crosslinkers, just like an epoxy resin or any synthetic polymer. The resin, which acts as a natural adhesive, has the potential to completely replace synthetic resins in the construction sector.

Advantages:
 Spinifex resin has waterproofing qualities making it an effective sealant. It can be heated up several times and is a natural insect repellent.

Disadvantages:
 No significant cultivation as resource available yet.

Latex

Raw Material:
 Latex (Rubber Tree).

Location:
 Sub-humid.

Use:
 Cladding, binding agent.

Description:
 Latex is a natural, renewable material derived from the rubber tree. Since the trees are not cut down during harvesting, their production is sustainable and carbon-negative. It is named after the sticky, milky white liquid produced by many plants to

protect themselves from pests: when the bark of a latex-bearing plant is damaged, latex coagulates to seal the scar while the bark regrows. Natural rubber latex, which is also used to produce natural rubber, is extracted via a process called tapping. This involves scoring the bark so that latex drips out into a receptacle (Hahn 2020). While rubber trees thrive in warmer, more humid climates, rubber tree cultivation is presently expanding rapidly into dry sub-humid areas. Although as a consequence, trees face a long dry season and low growth rates delay the start of tapping (Clermont-Dauphin et al. 2013).

Advantages:
 Natural rubbers have high strength, low hysteresis and good resistance to tearing as well as flexure. Latex or polymer latex can be added to mineral binders to form polymer-modified systems.

Disadvantages:
 Natural rubbers are easily affected by solvents, heat and UV.

7.3.6 Tannins and Lignin

Tannin-Based Rigid Foams

Raw Material:
 Wood extractives (e.g. *Acacia Ligulata*), chemical derivatives from hydrolysis of the hemicellulose, fermentation of simple sugars.

Location:
 Arid, semi-arid.

Use:
 Insulation

Description:
 Tannin-based rigid foams have been demonstrated to be effective thermal insulators for usage in the cavities of hollow-core wooden doors and other wooden cavities. Their thermal insulation capacity is comparable to that of completely synthetic, oil-derived foams such as polyurethanes, but they do not burn and so do not generate harmful gases when burnt. The weathering of wooden hollow-core constructions filled with tannin-based foams confirms that the wood in touch with the foam is unaffected by the foam's acidity due to the incorporation of an acid hardener used by co-reaction with the hardened polymer network.
 To create a tannin-based stiff foam, the foaming process is divided into three stages: mixing, expansion, and curing. The mixing process is critical for producing a homogeneous, very viscous bulk mix. All components (tannin extract, formaldehyde, furfuryl alcohol, blowing agent, additives, and water) are mixed mechanically until the system is homogeneous. When a catalyst (a strong acid) is introduced to the solution, the expansion phase begins. Furfuryl alcohol undergoes exothermic

self-condensation, as does the condensation of furfuryl alcohol, tannin extract, and formaldehyde. At the same time, the blowing agent, a low-temperature boiling solvent, evaporates as a result of the exothermic reaction's temperature increase. This foams the entire mixture, which has already begun to cure. The final stage is to cure the tannin/furfuryl/formaldehyde network, which will stabilise the foam in a matter of minutes (Tondi et al. 2008).

Advantages:

Good thermal insulators, that do not burn, and can be utilised to fill hollow-core doors for interior and exterior applications. They can be made directly in the cavity by injecting a liquid mixture and foaming the material in place. The weathering of wooden hollow-core structures filled with tannin-based foams confirms that the wood in touch with the foam is unaffected by its acidity.

Disadvantages:

Geographical availability is limited. Tannin extraction rates for most wood species are not economically viable since tannins are not globally available for industrial application. Furthermore, tannins have a high viscosity, a dark colour, and a variable composition that relies on the species, growth conditions, and harvesting time. Tannin changes aim to reduce viscosity for easy handling, increase pot life, and improve crosslinking (Hemmilä et al. 2017).

Tannin-Based Adhesives

Raw Material:

Wood extractives (e.g. *Acacia Ligulata*), chemical derivatives from hydrolysis of the hemicellulose, fermentation of simple sugars.

Location:

Arid, semi-arid.

Use:

Binding agent.

Description:

Tannins are naturally found in plant bark, wood, leaves, and fruits. Tannins are employed in a variety of industrial applications, primarily in the production of inks and textile dyes, as well as a corrosion inhibitor. Although tannin is found in many plant species, only a handful have a high enough concentration to warrant extraction. Tannin can be derived from a variety of plants, including pine, quebracho, oak, chestnut, wattle, eucalyptus, myrtle, maple, birch, and willow. There are various extraction methods employed, and the extraction method influences the adhesive qualities of tannin extracts. Tannin adhesives emit extremely little formaldehyde due to their phenolic nature.

Lignin and maize starch are two bio-based components that can be combined with tannins to make adhesives. Various crosslinking agents were employed to create low and non-emitting tannin wood adhesives. Tannin is distinct from other bio-adhesives. It has good adherence and can be used to produce panels that are more

resistant to moisture. As a result, its fundamental advantage is that it does not require any reinforcing from synthetic petroleum-based adhesives, and suitable crosslinkers have already been developed at both the laboratory and industrial scale. Because tannin has a limited pot life and is highly reactive, the goal of novel crosslinkers is to be less reactive than formaldehyde. As a result, hexamine, glyoxal, and tris(hydroxylmethyl)cnitromethane are excellent tannin-based adhesives (Hemmilä et al. 2017).

Advantages:
 Advantages include strong adhesion, quick curing, and water resistance.

Disadvantages:
 Insufficient geographical availability, hence low industrial application.

Lignin Based Adhesives

Raw Material:
 Shrubs, grasses, wood.

Location:
 Hyper-arid, arid, semi-arid, sub-humid regions.

Use:
 Binding agent.

Description:
 Lignin is an organic component that connects the cells, fibres, and vessels that makeup wood. Historically, the majority of accessible lignin has come as a byproduct of the pulping process. These lignin-derived fragments have a low value and are typically used as fuel in pulp and paper mill recovery boilers. The characteristics and water solubility of lignin generated from various techniques differ significantly. Lignin has mostly been utilised as a partial replacement for phenol in phenol–formaldehyde resins used in the manufacturing of plywood. The chemical structure of lignin reduces the reactivity of the resin, which is a drawback in applications requiring quick curing times. Among the most common chemical lignin modification processes are methylolation (hydroxymethylation), phenolation, and demethylation. Some authors have reported that lignin in combination with glyoxal, pMDI, or tannin can completely replace phenol–formaldehyde resin in particleboard manufacture (Hemmilä et al. 2017).

Advantages:
 Lignin is inexpensive and widely available.

Disadvantages:
 The biggest issue with lignin adhesives is their extremely poor reactivity, which results in extended pressing periods and hence higher production costs in panel manufacture.

References

Adams A (2015) The history of early materials. In: History of the book: disrupting society from tablet to tablet. CC BY-NC

Adebayo GO, Rahman N, Lafia-Araga R (2019) Influence of wood fiber surface chemistry on the tensile and flexural properties of heat-treated mangrove/high-density polyethylene composites. Polym Bull https://doi.org/10.1007/s00289-019-02731-0

Ahmed YH, Abdullatief S (2018) Use of gum Arabic (ACACIA SEYAL) as concrete admixture

Al-Adili A, Azzam R, Spagnoli G, Schrader J (2012) Strength of soil reinforced with fiber materials (Papyrus). Soil Mech Found Eng 48 https://doi.org/10.1007/s11204-012-9154-z

Ali M (2012) Natural fibres as construction materials. J Civil Eng Constr Tech 3(3):80–89 https://doi.org/10.5897/JCECT11.100

Amiralian N (2018) How a native desert grass can improve tyres, concrete, latex gloves and more. ABC Sci

Amorim C (2014) Curiosities—cork. http://www.amorim.com/en/. Accessed 19 Dec 2014

Aouf RS (2019) Viking-style seaweed thatch updated into prefab panelling. Dezeen

Ardente F, Beccali M, Cellura M, Mistretta M (2008) Building energy performance: a LCA case study of kenaf-fibres insulation board. Energy Build 40(1):1–10 https://doi.org/10.1016/j.enbuild.2006.12.009

Asdrubali F, D'Alessandro F, Schiavoni S (2015) A review of unconventional sustainable building insulation materials. Sustain Mater Tech 4 https://doi.org/10.1016/j.susmat.2015.05.002

'Baden-Württemberg' OP (2007–2013) European regional development fund. European Commission

Bagchi S, Rashmi Mano R, Thangam N (2018) Bamboo as a building material. Int J Latest Eng Res Appl (IJLERA) 03(07):17–19

Batog J, Bujnowicz K, Gieparda W, Wawro A, Rojewski S (2021) Effective utilisation of halophyte biomass from saline soils for biorefinering processes. Molecules 26(17):5393

Bornoma AH, Faruq M, Samuel M (2016) Properties and classifications of bamboo for construction of buildings. J Appl Sci Environ Sustain 2:105–114

Bruehl TA-M (2011) Sugarcane creations

Byg R (2013) The cultural heritage of Læsø: a resource in sustainable building. Realdania Byg

Caiazzo V (2013) Kenaf fiber for green building. Homexyou

Caldwell E (2008) From digester to backyard deck: turning manure fibers into construction material. Progresive Dairy

Campbell I, Macleod A, Sahlmann C, Neves L, Funderud J, Øverland M, Hughes AD, Stanley M 2019 The environmental risks associated with the development of seaweed farming in Europe-prioritizing key knowledge gaps. Front Marine Sci 6:107

Cannabric (2014) Hemp insulation. http://www.cannabric.com/. Accessed 29 Dec 2014

Canning J (2021) History and use of horsehair plaster. https://johncanningco.com/blog/horsehair-plaster/. Accessed 21 Jan 2021

Cheng HN, Ford C, Dowd MK, He Z (2016) Use of additives to enhance the properties of cottonseed protein as wood adhesives. Int J Adhes Adhes 68:156–160 https://doi.org/10.1016/j.ijadhadh.2016.02.012

Clermont-Dauphin C, Suvannang N, Hammecker C, Cheylan V, Pongwichian P, Do FC (2013) Unexpected absence of control of rubber tree growth by soil water shortage in dry subhumid climate. Agron Sustain Dev 33(3):531–538 https://doi.org/10.1007/s13593-012-0129-2

Coutts R (1987) Eucalyptus wood fibre-reinforced cement. J Mater Sci Lett 6:955–957 https://doi.org/10.1007/BF01729880

Dawit J, Regassa Y, Lemu H (2019) Property characterization of acacia tortilis for natural fiber reinforced polymer composite. Results Mater 5:100054 https://doi.org/10.1016/j.rinma.2019.100054

Debez A, Belghith I, Friesen J, Montzka C, Elleuche S (2017) Facing the challenge of sustainable bioenergy production: could halophytes be part of the solution? J Biol Eng 11:1–27 https://doi.org/10.1186/s13036-017-0069-0

Dhaliwal GS (2018) Soy-based polyurethane foam for insulation and structural applications. Missouri Univ Sci Tech Missouri

Dikmen N, Ozkan STE (2015) Unconventional insulation materials. In: Almusaed A, Almssad A (eds) Insulation materials in context of sustainability. IntechOpen. https://doi.org/10.5772/63311

Energy-Saver Oo (2012) Insulation materials

FOA 1985 Coconut wood—processing and use 57 FAO Technical Papers Rome

Gadhave RV, Mahanwar PA, Gadekar PT (2017) Starch-based adhesives for wood/wood composite bonding: review. Open J Polym Che 07(2):15. https://doi.org/10.4236/ojpchem.2017.72002

Gamage H, Mondal S, Wallis L, Memmott P, Wright B, Martin D, Schmidt S (2012) Indigenous and modern biomaterials derived from Triodia ('spinifex') grasslands in Australia. Austr J Botany 60:114–127 https://doi.org/10.1071/BT11285

Geoff V (2012) Scientists investigate Spinifex grass for alternative sustainable fiber. Science Network Western Australia

Gräbe G (2013) Seaweed under the roof. Fraunhofer Institute for Chemical Technology ICT—Research News Topic 2

Gromicko N (2021) Soy-based insulation. InterNACHI. https://www.nachi.org/soy-based-insulation.htm. Accessed 23 Jan 2021

Gum & Resins (2021) University of California. http://www.faculty.ucr.edu/~legneref/botany/gumresin.htm. Accessed 22 Dec 2014

Hahn J (2020) Latex "is a noble and natural material that does not kill animals"

Hebel DE, Wisniewska MH, Heisel F (2014) Building from waste: recovered materials in architecture and construction. Birkhäuser, Basel

Hemmilä V, Adamopoulos S, Karlsson O, Kumar A (2017) Development of sustainable bio-adhesives for engineered wood panels—a review. RSC Adv 7(61):38604–38630 https://doi.org/10.1039/C7RA06598A

Hu X, Cebe P, Weiss AS, Omenetto F, Kaplan DL (2012) Protein-based composite materials. Mater today 15(5):208–215

Insulation SW (2014) Where to use sheep wool insulation. https://www.sheepwoolinsulation.com/where-to-use/. Accessed 29 Dec 2014

Kayali O (2016) 21—Sustainability of fibre composite concrete construction. In: Khatib JM (ed) Sustainability of construction materials (2nd edn). Woodhead Publishing, pp 539–566. https://doi.org/10.1016/B978-0-08-100370-1.00021-4

Kruger L, Lacourse N (1990) Starch based adhesives. In: Skeist I (ed) Handbook of Adhesives. Springer, Boston, MA. https://doi.org/10.1007/978-1-4613-0671-9_8

Lekavicius V, Shipkovs P, Ivanovs S, Rucins A (2015) Thermo-insulation properties of hemp-based products latvian. J Phys Tech Sci 52(1):38–51 https://doi.org/10.1515/lpts-2015-0004

Lewis N (1992) Papyrus in classical antiquity: an update chronique d'Egypte 67(134):308–318 https://doi.org/10.1484/J.CDE.2.308909

Mansilla C, Pradena M, Fuentealba C, César A (2020) Evaluation of mechanical properties of concrete reinforced with eucalyptus globulus bark fibres. Sustainability 12(23). https://doi.org/10.3390/su122310026

Marino M (2011) Pacific's tree of life to rise again. Partners in Research for Development. Australian Centre for International Agricultural Research (ACIAR), Canberra

Mason F (1996) Vetiver grass for erosion and sediment control in the mackay area. Queensland

Nanakorn W, Chomchalow N (2006) Uses and Utilization of Vetiver Assumption University, Thailand Office of the President

NET NETC (2021) Biobased panels made from recycled cow manure. Noble Environmental Technologies Corporation [NET] http://nobleenvironmentalchina.net/about-ecor-sustainable-building-materials/?lang=en. 2021

Nicholson PT, Shaw I (2000) Ancient Egyptian materials and technology. Cambridge University Press, Cambridge, UK

Ozler L (2011) Material conneXion announces its MEDIUM award for material of the year. Dexinger

Pitman HT, Wallis LA (2012) The point of spinifex: aboriginal uses of spinifex grasses in Australia. Ethnobotany Res Appl 10:109–131

Plank J (2005) Applications of biopolymers in construction engineering. In: Biopolymers Online. https://doi.org/10.1002/3527600035.bpola002

Pradyawong S, Qi G, Li N, Sun XS, Wang D (2017) Adhesion properties of soy protein adhesives enhanced by biomass lignin. Int J Adhes Adhes 75:66–73 https://doi.org/10.1016/j.ijadhadh.2017.02.017

Roberts M (2014) Natural fibre from cotton. http://www.wildfibres.co.uk/. Accessed 29 Dec 2014

Savastano H, Warden PG, Coutts RSP (2000) Brazilian waste ®bres as reinforcement for cement-based composites. Cement Concr Compos 22:379–384

Sen T, Reddy HJ (2011) Application of sisal, bamboo, coir and jute natural composites in structural upgradation. Int J Innov Manag Tech 2(3):186–191 https://doi.org/10.7763/IJIMT.2011.V2.129

Søndermark J (2013) The modern seaweed house by Vandkunsten and Realdania Byg. Dezeen

Sutton A, Black D, Walker P (1999) Natural fiber insulation. University of Bath

Tadese S, Soromessa T, Bekele T, Berta A, Abebe G (2018) Production and challenges of gum arabic in Ethiopia: review. Nat Sci 8:33–45

Tondi G, Pizzi A, Olives R (2008) Natural tannin-based rigid foams as insulation for doors and wall panels. Maderas Ciencia y tecnología 10. https://doi.org/10.4067/S0718-221X2008000300005

WBPI WBPI (2018) Wood foam—a product on the rise?

WKI WRW-K-I (2020) Wood foam—from tree to foam—Fraunhofer WKI. Fraunhofer Institute for Wood Research, Wilhelm-Klauditz-Institut WKI. Accessed 29 Dec 2020

Yensen NP (2008) Halophyte uses for the twenty-first century. In: M.A. K, D.J. W (eds) Ecophysiology of high salinity tolerant plants. Tasks for Vegetation Science, vol 40. Springer, Dordrecht. https://doi.org/10.1007/1-4020-4018-0_23

Yuan X, Ji C, Wang X, Luo Z, Jin Y (2018) Research on the applicability of low-tech bamboo architecture in new rural construction. Paper presented at the MATEC Web of Conferences

Zhou X-y , Zheng F , Li H-g , Lu C-l (2010) An environment-friendly thermal insulation material from cotton stalk fibers. Energy Build 42(7):1070–1074 https://doi.org/10.1016/j.enbuild.2010.01.020

Chapter 8
Hybrid Materials

Abstract This chapter aims to compile an overview of traditional and emerging ecological composite materials found in deserts and drylands. These materials could be a hybrid of abiotic and biotic components or just one material group. The material resources are concentrated in hyper-arid, arid, semi-arid, and sub-humid regions. The selection of hybrid materials considers reducing resource consumption, the local abundance, and the thermal and structural capacities relevant to the bioclimatic surround. The five basic construction uses of materials considered in this chapter are structural system, infill, cladding or skin, and insulation or thermal mass.

Keywords Composite · Hybrid materials · Ecological resources · Drylands · Building

D. A. Ottmann, *Ecological Building Materials for Deserts and Drylands*,
SpringerBriefs in Geography, https://doi.org/10.1007/978-3-030-95456-7_8

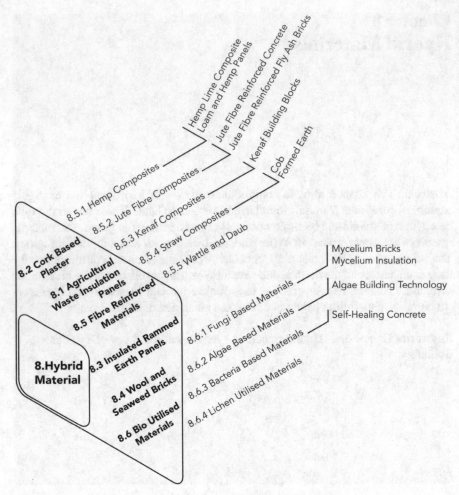

Hybrid materials overview

8.1 Agricultural Waste Insulation Panels

Raw Material:
 Agricultural crop waste, tannin-based adhesive

Location:
 Arid, semi-arid, sub-humid regions

Use:
 Insulation, cladding

Description:
Compressed agricultural by-products such as rice husks, peanut shells, wheat husks, barley husks, maize stalks, corn cobs, or corn husks are used to make agricultural waste panels. They can be used to create composite panels for a variety of purposes. The basic components are combined with an adhesive and pressed into a board under high pressure. The adhesive system in an all-organic product is based on tannin from tree bark. The panels can be made in a low-tech or high-tech manner. After harvesting, the raw material is left in its natural state and size in a low-tech technique (Hebel et al. 2014).

Advantages:
The raw ingredients are readily available, long-lasting, and affordable. The panels are also recyclable and help to avoid deforestation (Hebel et al. 2014).

Disadvantages:
Moisture and water absorption have crucial consequences.

8.2 Cork-Based Plaster

Raw Material:
Cork, clay, diatomaceous earth, hydraulic lime, fibres, water.

Location:
Semi-arid.

Use:
Insulation, cladding.

Description:
Cork-based plaster as a high-dehumidifying capacity, formulated with pure natural hydraulic lime, cork, clay and diatomaceous earth. It is frequently used to dehumidify and restore walls that have been harmed by growing humidity. A dehumidifying plaster with thermal qualities that is totally permeable and hygroscopic, meaning it can collect and release moisture without being destroyed. As a result, it contributes to energy conservation by limiting interstitial condensation and, as a result, the amount of humidity to be disposed of. Moisture in the masonry is quickly absorbed and moved outwards when it comes into touch with the dehumidifying system.

This is the start of the drying process, which will take some time. Because of the porosity of the material, the system's integrity is preserved. It effectively inhibits the passage of salts, allowing only moisture to pass through. The salts are reabsorbed by the brickwork as a result of osmosis, preventing the plaster porosity from becoming saturated. The porous structure of cork-based plaster, together with its high permeability and quick capillary absorption, ensures that the wall is dehumidified. It can be applied by hand or with conventional pumps for premixed materials, and it takes 15 days to dry entirely (Diasen 2014).

Advantages:
Cork-based plaster has a high capacity of water absorption in combination with excellent breathability, acoustic absorption and fire resistance.

Disadvantages:
With and without hydrophobization, lime-cork-based insulating plaster has shown significant relative humidity and the danger of moisture-induced issues (Jensen et al. 2020).

8.3 Insulated Rammed Earth Panels

Raw Material:
Earth (loam), foam glass gravel, casein, lime.

Location:
Hyper-arid, arid, semi-arid, sub-humid regions.

Use:
Wall system.

Description:
Prefabrication in earth construction is a response to today's typical building process, which, because to time constraints and labour costs, provides little room for on-site manufacture (Rauch 2021). An example of prefabricated earth construction are the sandwich panels of rammed earth and foam glass that were made in panels of 3.5 × 1 m size and a total thickness of 69 cm at the new Alnatura headquarters in Darmstadt. They consist of two rammed earth shells with a 17 cm thick insulation layer in-between made of foam glass gravel obtained from recycled glass. On the interior, a casein coating was used to decrease abrasion, and on the outside, horizontal erosion barriers consisting of thin layers of trass lime, spaced at 30–60 cm intervals, were used to reduce the quantity of earth that washed away by rain. Modular formwork is filled with loose material and tamped down to create the rammed earth components. Rammed earth units are built as 30 m long blocks that are then chopped into individual 3.5 m blocks once the formwork is removed to save time and money. Filling and tamping is done 13–14 times for every metre of wall height. A composite pipe is manually installed on top of each layer of rammed earth, and vertical distribution pipes are routed through the window reveals.

The bond between the loam and the foam glass does not require any additional binding agent. When the gravel is filled, it is still quite coarse (grain size 10/75 mm) and is crushed during tamping, causing it to mesh with itself and the ground mass (Schoof 2019).

Advantages:
The progress and improvement of the prefabricated rammed earth technique have improved efficiency on the construction site, made scheduling more precise, and

made projects more feasible. Because the drying process takes place entirely in the production hall, this method allows for weather-independent production. Construction coordination on site is thus easier and more accurately foreseeable. This combination allows for a perfect match in industrialised construction processes, and it has the ability to be optimised and rationalised using modular systems.

Disadvantages:

When the supply of heavy material transported over vast distances is taken into account, earthen buildings are significantly worse than the usual option in terms of embodied energy. This emphasises the need to utilising local resources when undertaking large-scale construction projects (Schoof 2019).

8.4 Wool and Seaweed Bricks

Raw Materials:

Clay, unprocessed wool, alginate.

Location:

Hyper-arid, arid, semi-arid, sub-humid regions.

Use:

Structural system, infill.

Description:

Bricks can be reinforced with wool and alginate to create a composite that is more sustainable, non-toxic, and uses readily available local materials while also improving the mechanical strength of the bricks (Liggett 2010).

Alginate (a natural polymer derived from the cell walls of brown algae) serves as the composite's bonding agent. Reinforcement is provided by sheep's wool. Wool fibres are mixed into the clay used in the bricks resulting in a composite material that is appropriate for damp climates. The composite was shown to be 37% stronger than conventional bricks created with unfired stabilised earth in mechanical tests. Seaweed fibres boost the strength of compressed bricks, limit the creation of fissures and deformities as a result of contraction, shorten drying time, and raise the bricks' flexion resistance. (Galán-Marín et al. 2010).

Advantages:

Because wool and seaweed bricks do not need to be burnt, they use a lot less energy in the manufacturing process. They are 37% stronger than other bricks created with unfired stabilised earth and are ideal for harsh climatic conditions.

Disadvantages:

No disadvantages are noted.

8.5 Fibre-Reinforced Materials

8.5.1 Hemp Composites

Loam and Hemp Panels

Raw Material:
 Loam and clay, hemp, mineral oxide, vegetable binder.

Location:
 Arid, semi-arid.

Use:
 Cladding.

Description:
 Loam and hemp building panels can be used as base layer for loam. They are made out of loam and clay, hemp, 30% mineral binders (mineral oxide), and a vegetable binder that is been certified for use in food. The panels are utilised for planking of wooden and metal stand structures of interior walls, facing shells, ceilings, and roof surfaces, and are waterproof and moisture regulating. They are solid and stable, with sharp edges, dimensional precision, and water resistance. Screws can be used to secure them to the wall. Their water resilience also enables the application of thick clay plaster layers (Claytec 2019).

Advantages:
 Clay is abundant worldwide and widely available locally. Hemp-clay is a lightweight material that is absolutely safe to handle, reusable, and biodegradable.

Disadvantages:
 High humidity can contribute to mould formation; thus, water should be kept to a bare minimum. It is also important to pay attention to the drying time. It is possible that shrinkage will be an issue (Busbridge and Rhydwen 2010).
 Hemp Lime Composite

Raw Materials:
 Water, hemp shiv, lime binder.

Location:
 Sub-humid regions.

Use:
 Insulation, cladding.

Description:
 A building product with high thermal insulating and acoustic qualities can be made by simply combining water, hemp aggregate, and a lime-based binder. With a fully encased load-bearing timber frame, the insulation forms the whole wall. Hemp Lime composite is more than simply an insulator; it also regulates temperature

and humidity, inhibits damp and mould growth, and creates a comfortable, healthy environment in the structure. Shiv, the woody core of the plant stalk, is used in composites. Hemp Lime's fundamental job in construction is to form an insulating barrier that protects against the cold, heat, noise, and humidity of the outside world. Hemp Lime has also been reported to passively regulate the interior temperature and relative humidity of buildings within acceptable limits (Technology 2019).

Hemp Lime is made up of three primary ingredients: Hemp shiv - The woody core of the plant stalk known as Shiv makes up 40–60% of the Cannabis Sativa L. plant by mass in HL composites. Hemp is produced as a break crop for 3–4 months before being harvested. After being gathered and bailed, the hemp is taken to a processing plant where the shiv is separated from the fibre and any dust, dirt, and other impurities are removed. Hemp fibre is currently used primarily in the automotive, paper, and textile industries.

Binder - This establishes a matrix connection between the shiv particles. Binders have been specifically designed for use with HL by adding hydraulic components and other additives to generate a rather fast initial hydraulic set on site, despite being mostly constituted of lime. Carbonation of the lime occurs once it is blended into the composite, changing calcium hydroxide to calcium carbonate. The CO_2 absorbed partially compensates for the CO_2 emitted during the binder's synthesis. In order to activate the reactive components inside the binders, potable water is required. Hemp Lime is most commonly used in non-structural applications, where it is cast or sprayed over a primary structural frame made of wood. After the material has been cast or sprayed in place to a thickness of 250–500 mm, it is allowed to cure for a few days before a suitable (typically lime-based) render finish is placed directly to the Hemp Lime (Hirst et al. 2010).

Advantages:

Hemp Lime has the advantage of being entirely breathable and hygroscopic, which helps to regulate humidity (Wooley 2014). Hemp Lime composites are fire and termite resistant, lightweight, and produces a hard wall surface while being vapour permeable to assist decrease humidity and condensation. Because it does not crack significantly when moved, it is suitable for usage in earthquake-prone areas.

Disadvantages:

Low compressive strength and requires a certain amount of training (Jami et al. 2019).

8.5.2 Jute Fibre Composites

Jute Fibre-Reinforced Concrete

Raw Materials:
Jute fibre (*Tiliaceae*), sand, cement, stone, water.

Location:
Arid, semi-arid.

Use:
 Structural system.

Description:
 Jute-reinforced fibre is a novel material that provides compressive strength while also preventing crack propagation in constructions. Jute-reinforced fibre is renewable in nature, unlike glass or polymer fibres, and the energy used to melt glass or make polymer can be saved. Jute-reinforced fibre is chopped into little 4–6 mm fibres and is around 2–3 m long. After that, the fibres are chemically treated to make them more stable. Hemicellulose and other sugars, including lignin, are eliminated during the chemical treatment, loosening the fibrils and cellulose molecules; that is, fibre becomes fibrillated into fibrils.

 These fibrils are made up of cellulose molecules with hydroxyl groups linked together with hydrogen between them. These hydroxyl groups interact with the cement in the concrete, causing polymer and chemical bonding in the process. Between the fibre and the cement, a polymer functions as a bridging agent. After that, a concrete matrix made up of cement, sand, and stone in the form of coarse and fine aggregates is created. After that, the chemically treated material is distributed throughout the concrete mix. The concrete is cured for 28 days after it has been laid, increasing its strength (Majumder and Adhikari 2013).

Advantages:
 Jute-reinforced fibre has a higher compressive strength. It is particularly useful in seismic zones; during an earthquake, the fractures reduce the shaking and keep the building intact for a longer length of time.

Disadvantages:
 As with other fibres, incorporating jute fibres into the cement matrix is labour-intensive, making it more expensive than producing plain concrete.

Jute Fibre-Reinforced Fly Ash Bricks

Raw Materials:
 Jute fibre (*Tiliaceae*), fly ash, water.

Location:
 Arid, semi-arid.

Use:
 Infill.

Description:
 In the development of fly ash bricks, jute-reinforced fibre can be used. Fly ash, a finely split residue arising from the burning of ground or powdered bituminous coal or sub bituminous coal (lignite), is combined with these bricks and transported by the flue gases of boilers powered by pulverised coal or lignite (Salla et al. 2013). Because fly ash lacks its natural binding properties, it must be spread using jute-reinforced fibre. These jute bricks are sprayed with water to increase their strength and become hydraulic in nature (Majumder and Adhikari 2013).

The compressive strength of the brick increases as the percentage of jute fibre in the brick increases (Salla et al. 2013). Fly ashes are pozzolanic materials, which means they react with water and lime (CaO) to produce cement. Some fly ashes contain enough 'free lime' to operate as a self-cementing material (Nataatmadja 2008).

Advantages:
 The use of fly ash and natural fibres helps to reduce environmental deterioration and the usage of agricultural land in the production of clay bricks. The bricks do not absorb heat, making them ideal for hot areas.

Disadvantages:
 Not all fly ash is suitable for construction.

8.5.3 Kenaf Composites

Kenaf Building Blocks

Raw Materials:
 Kenaf (*Hibiscus cannabinus*), magnesium oxychloride cement, water.

Location:
 Semi-arid.

Use:
 Infill.

Description:
 Kenaf fibres are emerging as alternative building materials either to complement or replace wood and fibreglass but also as reinforcing components to hybrid materials. The approach involves combining kenaf, an agricultural fibre, with magnesium oxychloride cement, an organic binder, and water to create a matrix that can be placed in moulds to generate the blocks in a low-energy and cost-effective procedure. The resulting blocks are lightweight and robust.
 The bast fibres (outer fibre of the stalk), and core fibres (whit inner fibre) are ground and finely processed before the mix with the magnesium oxychloride cement is poured into moulds as lightweight solid mass with great compressive strength. After compaction and vibration, they are left for 24 h before being taken from the moulds. The blocks are left to cure at room temperature. According to preliminary cost estimates, the cost of producing kenaf blocks could be comparable to the cost of concrete masonry units (Arumala 2014).

Advantages:
 Apart from kenaf being a carbon sink, the manufacturing process is low-energy and cost-effective. The resulting blocks are both light and sturdy.

Disadvantages:
Difficulties in processing kenaf fibres and determining the best oxychloride design mix may be encountered.

8.5.4 Straw Composites

Formed Earth

Raw Materials:
Clay soil, straw or woodchip, timber.

Location:
Semi-arid.

Use:
Infill.

Description:
This method calls for a liquid clayey soil that is poured over cut straw. After that, the mixture is usually manipulated into shapes. These are not load-bearing walls; they are light, have a high thermal insulation value, and have to be built in a wooden structure. The term 'straw clay' is commonly used to describe it. Straw clay can be used as a filler wall or as prefabricated blocks between two wooden structures (AVEI 2021).

Advantages:
The poor thermal conductivity of straw clay provides excellent thermal insulation, lowering energy consumption and CO_2 emissions from heating and cooling. Straw clay walls can be built with relatively simple tools and technologies that are widely available. Finally, the walls can securely disintegrate without becoming landfill when they have been deconstructed (Holzhueter and Itonaga 2017).

Disadvantages:
The construction approach can take longer than traditional construction, which raises labour costs.

Cob

Raw Materials:
Clayey sub-soil, straw, water.

Location:
Semi-arid, sub-humid regions.

Use:
Structural system, infill.

Description:

Clay content varies greatly among subsoils. The percentage of clay in a suitable soil should be between 10 and 25%. Stones, gravel, sands, and silts make up the remaining portion. During the mixing process, straw is utilised as a binder to aid with manageability and to spread shrinkage cracks when the material dries. Straw (often referred to as barley) will also provide structural capabilities and overall wall mass reinforcement. In order to obtain a flexible and workable consistency, water is required during the mixing process (Cornell 2020).

The mixture is frequently shaped into balls and layered on top of each other (AVEI 2021). Mud and straw are placed in the wall without the use of any forms or moulds, resulting in a rough and unshapely wall that is afterwards trimmed true and reasonably smooth. Without the use of formwork, cob walls are constructed by putting lumps of cob mix by hand to create gigantic walls that are typically 450–600 mm thick and built up in layers. Each layer must be completely dried before moving on to the next. It is perfect for creating free-flowing sculptural forms. To reduce movement and cracking, and to keep the base of the walls dry, cob walls require sturdy footings. For weather protection, they must be whitewashed (lime and water) (Downton 2013).

Advantages:

It is inexpensive. According to Downton (2013), the walls offer good natural insulation and are fireproof.

Disadvantages:

Lab-intensive practice and a delayed construction procedure are disadvantages.

8.5.5 Wattle and Daub

Raw Materials:

Wet soil, clay, sand, animal dung, straw, frame of bush timbers (or reeds, sticks or bamboo), horse urine as possible stabiliser.

Location:

Semi-arid, sub-humid regions.

Use:

Cladding.

Description:

The Neolithic period saw the use of the wattle and daub technique. It has been used for at least 6000 years. Construction techniques like lath and plaster, and even cob, are thought to have evolved from wattle and daub. In Africa, Europe, Mesoamerica, and North America, wattle and daub construction fragments have been discovered. (Shaffer 1993).

As traditional wall-building technique in which a woven lattice of hardwood strips (wattle) is daubed by hand with a sticky material, usually a mixture of moist soil, clay, sand, animal dung, and straw. Typically, a load-bearing wooden frame is built first, followed by wattle and daub wall panels between the wooden supports (Fielding 2012).

Infill wall panels are used to close a load-bearing structure, which is usually composed of wood. The latter is built of a lattice with a plastic dirt glued on both sides. The earth is held in place by the lattice frame, which also provides sturdy panels. Reeds, sticks, or bamboo are commonly used to create this lattice. It has been widely utilised in many parts of the world, including both developing and developed countries. The Auroville Earth Institute AVEI (2021) describes the earthen ingredients were often stabilised with horse urine in France (Normandie and Bretagne): the ammonia contained in the urine gave the soil water resistant characteristics to a degree.

Advantages:
It is not complex to build and only basic carpentry skills are required.

Disadvantages:
Poor insulation.

8.6 Bio-Utilised Materials

8.6.1 Fungi Based Materials

Mycelium Bricks

Raw Material:
Fungal mycelium, sawdust or other agricultural waste.

Location:
Arid, semi-arid, sub-humid regions.

Use:
Infill.

Description:
Fungi create a large network of thin, root-like fibres called mycelium under the ground's surface. Mycelium that has been dried can be utilised to create a super-strong, mould-resistant, and fire-resistant building material. It can be grown and shaped into almost any shape, and its incredible consistency makes it stronger than concrete pound for pound (Boyer 2014). Mushrooms consume cellulose and convert it to chitin, the same ingredient used to make insect shells.

The bricks have the texture of a composite material, with a spongy cross-grained pulp core that becomes denser as it approaches the outside skin. The skin is extremely

tough, shatter-resistant, and capable of withstanding extreme compression. Mushrooms are cultivated by stuffing sawdust into sealed bags and steam heating them for a few hours. Small bits of mushroom tissue are put into the bag once the pasteurised wood chips have cooled, and the bag greedily devours the neutralised wood.

The fungus hardens into a mass of interlocking cells as it digests and converts the contents of the bag, gradually becoming denser and adopting shape. Mushrooms, like plaster or cement, can be cast into practically any shape. It takes two to four weeks for the fungus to consume the sawdust and harden in a bag. The fungus is placed in a growing room when it has formed. The bags' tops are cut off, and the fungus is permitted to develop for a week in a high humidity setting. After that, the bricks are dried (Ross 2014).

Advantages:
Mycelium bricks are 100% organic and compostable. Once dry, the material is light. They are also fireproof, non-toxic, mould resistant, and water resistant to a degree.

Disadvantages:
Mycelium's water resistance deteriorates over time, rendering it susceptible to mould and dampness.

Mycelium Insulation

Raw Material:
Fungal mycelium, agricultural waste.

Location:
Arid, semi-arid, sub-humid regions.

Use:
Insulation

Description:
Agricultural by-products and mushroom mycelium are used to make this product. Fungi's vegetative growth stage is called mycelium. There are no spores used in this method. Mycelium is a self-assembling, natural adhesive that is also fire resistant. Clean plant by-products such as stalks and seed husks can be used as agricultural waste mycelium insulation and is an alternative to plastic foams, which have major environmental consequences. Living mushroom insulation can also be used to fill wall components and grown in place under temperature-controlled circumstances. Over the period of about a month, the insulation solidifies, sets, and dries out (Mayoral 2011).

Advantages:
Mycelium insulation is fireproof, non-toxic, partly mould and water resistant. With a low thermal conductivity, mycelium performs well as lightweight insulation material (e.g. fungus species *Oxyporus latermarginatus* in combination with straw achieves 0.078 W/(mK)) (Xing et al. 2018).

Disadvantages:

The water resistance of mycelium decreases over time, making it vulnerable to mould and humidity.

8.6.2 Algae Based Materials

Algae Building Technology

Raw Material:
Microalgae.

Location:
Arid, semi-arid, sub-humid regions.

Use:
Cladding.

Description:

Novel architecture has implemented algal building technology in the shape of façade panels that operate as a source of energy for heating the flats and providing hot water as part of the International Building Exhibition in Hamburg in 2006. The structure is essentially made up of a series of bioreactor façade panels or 'pools,' each of which contains microalgae. The algae create biomass and catch solar thermal heat, both of which can be gathered and transformed into usable energy for the structure (Johnson 2016).

The harvested thick pulp of microalgae can be fermented in an external biogas plant and utilised to generate biogas once again. In addition, the façade offers the traditional functions of sound, heat, and cold insulation, as well as providing shade in harsh sunlight.

Advantages:

Algae are particularly well-suited to this procedure because they produce up to five times as much biomass per hectare as soil-grown plants and contain a particularly high proportion of oils that can be used to generate electricity. There is a lot of potential for solar heat and hot water production, biofuel production, and sewage treatment to help reduce the high levels of glasshouse gas emissions from the built environment.

Disadvantages:

Accidental leakage and contamination, as well as the possibility of odours, must be considered. There is a risk of water warming in a desert or dryland setting, therefore algae selection is crucial in this regard (Wilkinson et al. 2017).

8.6.3 Bacteria Based Materials

Self-Healing Concrete

Raw Material:
 Bacteria, alkali-resistant, spore-forming.

Location:
 Hyper-arid, arid, semi-arid, sub-humid regions.

Use:
 Structural systems.

Description:
 The metabolic conversion of calcium lactate to calcium carbonate in bacteria-based self-healing concrete seals existing fissures. This biochemically mediated method, which uses bacteria's waste product, effectively seals sub-millimetre fissures. Both the bacteria and a bio-cement precursor component, which serves as their food, must be integrated into the material matrix prior to pouring, and only activated when a fracture occurs, for effective self-healing (Hebel et al. 2014).

Advantages:
 According to Vijay et al. (2017), utilising bacteria reduces water penetration and chloride ion permeability in concrete, and bacteria improve the compressive strength of Portland cement mortar cubes and concrete. Furthermore, 'microbial concrete' can be a high-quality alternative concrete sealer that is cost-effective, environmentally friendly, and improves the lifetime of construction materials.

Disadvantages:
 To safeguard microorganisms in concrete, precautions should be taken. There are a lot of requirements that must be completed and might elevate cost.

8.6.4 Lichen Utilised Materials

Raw Material:
 Lichen.

Location:
 Hyper-arid, arid, semi-arid, sub-humid regions.

Use:
 Cladding.

Description:
 A lichen is a plant that grows as a result of a symbiotic relationship between certain fungus and (typically) green algae. It is also possible to find lichens containing cyanobacteria. Lichens can be found in a variety of settings, including some that are

quite harsh (Antarctic-Program 2016). Photosynthesis allows lichen to filter sunlight, gather moisture and nutrition for their hosts, and eliminate contaminants from the air. Lichen is a hypersensitive organism that retreats or dies in unfavourable or contaminated settings but swiftly spreads its nett in favourable conditions. Lichens are grown on buildings to reduce cumulative temperatures by absorbing sunlight and reflecting heat due to their light colour palette, while also producing oxygen and providing green space on the sides of buildings. Lichen has no roots and develops vertically on permeable surfaces as a mixture of fungi and algae. It grows best at high altitudes, where it can survive droughts by absorbing water from the air. The lichen is applied to the buildings by painting a lichen slurry, a watery mixture, on the sides. The lichen propagates in about three months after the slurry is placed in situ. The lichen will just dry up and blow away if it does not take (Stribling 2011).

Lichen can be utilised to support the natural, rapid proliferation of pigmented organisms in biological concrete. Lichen utilised bio concrete cladding material, which was developed for building facades or other structures in climates with low precipitation, providing environmental, thermal, and aesthetic benefits over other similar construction alternatives (UPC 2012).

Advantages:

Lichens require very little maintenance (Cruz and Beckett 2015). The material enhances building thermal comfort while also lowering CO_2 levels in the atmosphere.

Disadvantages:

A few lichen species are eaten by insects or larger animals.

References

Antarctic-program (2016) Lichens

Arumala J (2014) Kenaf building blocks. In: Paper presented at the 121st ASEE annual conference and exposition, Indianapolis, 15–18 June 2014

AVEI TAEI (2021) Building with earth. UNESCO chair "earthen architecture, constructive cultures and sustainable development". https://www.earth-auroville.com/world_techniques_intr oduction_en.ph. Accessed 24 Sept 2021

Boyer M (2014) Philip Ross molds fast-growing fungi into mushroom building bricks that are stronger than concrete. Inhabitat. http://inhabitat.com/phillip-ross-molds-fast-growing-fungi-into-mushroom-building-bricks-that-are-stronger-than-concrete/

Busbridge R, Rhydwen R (2010) An investigation of the thermal properties of hemp and clay monolithic walls. In: Paper presented at the advances in computing and technology, (AC&T) the school of computing and technology 5th annual conference. University of East London, 01/01

Claytec (2019) CLAYTEC GREENTECH 700. Claytec e.K., 41751 Viersen. https://www.cla ytec.de/Produkte/Bilder-und-Dokumente/3_Lehm-Trockenbau/Claytec-Greentech-700/Produk tblatt-Greentech-700/09-016.pdf. Accessed 7 Jan 2021

Cornell L (2020) What is Cob? http://www.cornellcob.co.uk/cob/what-is-cob.html. Accessed 26 Dec 2020

Cruz M, Beckett R (2015) The future of architecture: moss, not mirrors plants and lichens on a concrete wall used to be a sign of decay, but soon they might be a sign of sophistication. The Atlantic

Diasen (2014) Diasen diathonite deumix. https://www.slideshare.net/konsiteo/diasen-diathonite-deumix. Accessed 20 Dec 2014

Downton P (2013) Your home, Australia's guide to environmentally sustainably homes. Commonwealth of Australia Department of Industry, Science, Energy and Resources

Fielding R (2012) Review of sustainable building materials and design. Lessons to date and recommendations. Build Int

Galán-Marín C, Rivera-Gómez C, Petric J (2010) Clay-based composite stabilized with natural polymer and fibre. Constr Build Mater 24(8):1462–1468. https://doi.org/10.1016/j.conbuildmat.2010.01.008

Hebel DE, Wisniewska MH, Heisel F (2014) Building from waste: recovered materials in architecture and construction. Birkhäuser, Basel

Hirst E, Walker P, Paine K, Yates T (2010) Characterisation of low density hemp-lime composite building materials under compression loading. In: Paper presented at the second international conference on sustainable construction materials and technologies, Acona, Italy

Holzhueter K, Itonaga K (2017) The potential for light straw clay construction in Japan: an examination of the building method and thermal performance. J Asian Archit Build Eng 16(1):209–213. https://doi.org/10.3130/jaabe.16.209

Jami T, Karade SR, Singh LP (2019) A review of the properties of hemp concrete for green building applications. J Clean Prod 239:e117852. https://doi.org/10.1016/j.jclepro.2019.117852

Jensen NF, Rode C, Andersen B, Bjarløv SP, Møller EB (2020) Internal insulation of solid masonry walls—field experiment with Phenolic foam and lime-cork based insulating plaster. E3S Web Conf 172

Johnson N (2016) Future building materials: algae facades and phase change concrete. Arch Des

Liggett B (2010) Researchers develop eco super bricks made of wool. Inhabitat. http://inhabitat.com/researchers-develop-eco-super-bricks-made-of-wool/. Accessed 10 Nov 2014

Majumder SB, Adhikari B (2013) The jute way. Mater Adv. Construction World

Mayoral E (2011) Growing architecture through mycelium and agricultural waste. Int J Constr Environ 1(4)

Nataatmadja A (2008) Development of low cost fly ash bricks. In: Paper presented at the CIB W89—International conference on building education and research (BEAR), June

Rauch M (2021) Rammed-earth walls|Loam clay earth. Lehm Ton Erde, Martin Rauch, Vorarlberg. https://www.lehmtonerde.at/en/products/product.php?aID=70. Accessed 01 Sept 2021

Ross P (2014) Mycotecture. https://www.moma.org/interactives/exhibitions/2013/designandviolence/mycotecture-phil-ross/. Accessed 17 Nov 2014

Salla S, Pitroda DJ, Shah D (2013) Comparative Study on Jute Fibre Banana Fibre in Fly Ash Bricks. 4:850–856 ISSN: 2231–5381 http://wwwijettjournalorg

Schoof J (2019) Building with earth at large scale. DETAIL Magazine. DETAIL Business Information GmbH, Munich, Germany

Shaffer GD (1993) An archaeomagnetic study of a wattle and daub building collapse. J Field Archaeol 20(1):59–75

Stribling DC (2011) Professor greens buildings with lichens. MHN—multi-housing news

Technology AL (2019) What is hempcrete? http://www.americanlimetechnology.com/what-is-hempcrete/. Accessed 01 Sept 2021

(UPC) UPdC (2012) Biological concrete for constructing 'living' building materials with lichens, mosses. ScienceDaily. www.sciencedaily.com/releases/2012/12/121220080310.htm.

Vijay K, Murmu M, Deo SV (2017) Bacteria based self healing concrete–a review. Constr Build Mater 152:1008–1014

Wilkinson S, Stoller P, Ralph P, Hamdorf B, Catana L, Kuzava G (2017) Exploring the feasibility of algae building technology in NSW. Proc Eng 180:1121–1130. https://doi.org/10.1016/j.proeng.2017.04.272

Wooley Y (2014) The growth of hemp lime as a natural building method. Last Straw—Int J Straw Bale Nat Build

Xing Y, Brewer M, El-Gharabawy H, Griffith G, Jones P (2018) Growing and testing mycelium bricks as building insulation materials. In: IOP conference series: earth and environmental science vol 2. IOP Publishing, p 022032

Chapter 9
Potentials for New Ecological Building Materials in Deserts and Drylands

Abstract Based on the findings of various abiotic, biotic and hybrid building materials adhering to ecological standards, we are identifying further needs and demands for the development of exiting raw matters. The tradition has made use of a limited choice of materials but has equally invented ingenious mixes of biotic and abiotic sources, resulting in ecological composite materials. We discuss ecological composite building materials and a combination of previously listed biotic and abiotic resources in drylands. As potential ingredients for future ecological composites suitable for drylands, we rearrange those into categories of binder/matrix and reinforcement/filler.

Keywords Ecological Materials · Composites · Tradition · Technology · Culture · Circularity

9.1 Combining the Best of Two Worlds

The combinatory matrix in Fig. 9.1 of all-natural materials collected in the previous chapters reveals that the listed hybrid materials pose combinations of biotic and abiotic resources combined into one building material (e.g. biotic woven fibres daubed with animal biomass, more fibres and sticky abiotic loam resulting in 'Wattle and Daub' see Sect. 8.5.6). These hybrid materials could also be referred to as composition materials or in short, composites.

A composite material is a substance made up of two or more constituent materials and is bonded together. These constituent materials have markedly different chemical or physical properties, and when combined, they form a material with features not found in the individual constituents (Matthews and Rawlings 1999). Individual elements remain distinct and unique inside the completed structure, distinguishing composites from mixes and solid solutions. The matrix phase and reinforcement phase of parent materials are the most common distinctions. The matrix binds the reinforcing material together and distributes the load among them, while the reinforcement is the load-carrying member. A composite could thus be made up of clay and rocks, but our minds are usually drawn to more extravagant systems. Sophisticated composites are made up of synthetic polymers and advanced engineering

© The Author(s), under exclusive license to Springer Nature Switzerland AG 2022 113
D. A. Ottmann, *Ecological Building Materials for Deserts and Drylands*,
SpringerBriefs in Geography, https://doi.org/10.1007/978-3-030-95456-7_9

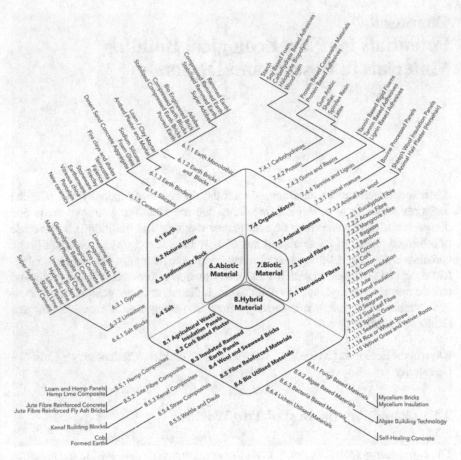

Fig. 9.1 Combinatory Matrix of Abiotic (Chap. 6), Biotic (Chap. 7) and Hybrid Materials (Chap. 8)

fibres, or plant fibres made up of natural polymers like cellulose, hemicelluloses, and lignin.

Composite classification can be done in a variety of ways. The distinction between 'natural' and 'synthetic' composites is one of the most basic classifications. Natural polymer composites, such as woody plants (bamboo, palms trees), are viewed as (eco-locally) superior to (fossil fuel-based) polymer composites created through chemical synthesis. Another distinction can be drawn between 'traditional' and 'synthetic.' Traditional materials include wood, but also simple composites like Portland cement mixed with sand or gravel aggregate, whereas synthetic materials include glass-epoxy, carbon fibre-reinforced polymers, and other sophisticated materials (Stokke et al. 2013).

In this publication, we focus on ecological perspective so 'traditional' in combination with 'natural' where nonetheless sophisticated findings can be made once

utilising biological aggregates and bioprocessing without compromising toxic ingredients and emission prone fossil fuel-based binders such as synthetic polymer resins.

Historically earth as the matrix was reinforced with wattle (of all kinds of biotic fibres) to 'Wattle and Daub' (8.5.5), which counts as one of the oldest composites besides cob, adobe, plywood, concrete (of lime mortars in combination with pozzolana, e.g. *Sarooj*). With the introduction of petrochemicals in the early nineteenth century, artificial polymers (like Bakelite, later polymer and epoxy resins) were introduced as matrix for, e.g. glass fibres (resulting in Glass Fibre-reinforced Plastics GRP). From here on synthetic composites revolutionised the world with new lightweight and strong materials that can be used for boats, automobiles and aeronautical applications and shaped into any form imaginable.

The overview of materials listed in Fig. 9.1 also reveals that most combinations are between fibres and earth (cob, loam hemp, wattle and daub, etc.) and other fibre-reinforced materials (often as lime-based concrete mix, e.g. HempCrete). Yet, the contemporary version of material systems used in drylands—like in the rest of the world—rely now predominantly on the climate change enhancers steel and Portland Cement-based concrete.

Inspired by the holistic interrelationship of passively designed buildings in deserts (see Chap. 4) in a specific cultural context (see Chap. 3) where the affinity to local nature and resources (Chap. 5) was clearly interwoven into the architectural design decisions, the rearrangement of the selected natural materials (Chaps. 6–8) shall reveal a plethora of new opportunities for future renewable, low-emitting, ecological material compositions.

9.2 New Composition for Ecological Materials from Renewable and Sustainable Resources

In today's world, composite materials, both natural and manufactured, are used in a wide range of applications. Composites cover a wide range of engineered materials and products, from building materials to automobile components and medical devices to aircraft bodies and spacecraft. Some composites combine synthetic fabrications with naturally occurring lignocellulosic composite material to achieve the material performance required by a specific application. However, natural, plant-based and fibre-based materials are frequently overlooked when discussing this broad category of materials. Nonetheless, lignocellulosic composite materials already play an important role in structural and non-structural building applications such as windows, doors, cabinetry, furniture, or packaging and shipping containers.

Through summarising an exhaustive but never completed array of potential raw materials from abiotic sources such as earth, natural stone, sedimentary rock, and even salt minerals in combination with an enlarged array of biotic matter around wood

and non-wood-fibres, animal biomass and plenty of organic matrices, formulations of further developed ecological material combination can be found.

The listed ecological hybrid materials in Chap. 8 are existing composite materials and incorporate many of the listed abiotic and biotic materials related to drylands; however, the listings in Chaps. 6 and 7 promise potential to combine even more possible hybrid or composite materials. Hence in Fig. 9.2, we have reorganised all previously described abiotic and biotic materials compatible with deserts and drylands into categories describing the matrix phase as Binder or Matrix and the reinforcement phase as Reinforcement or Filler. With this rearrangement, combinations for (new) hybrid materials as eco-composites become possible.

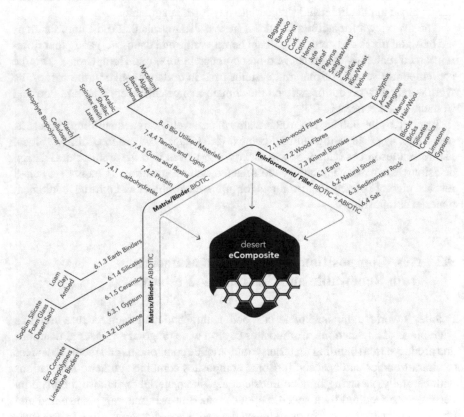

Fig. 9.2 Eco-Composites Ingredients for Deserts and Drylands

9.3 Eco-Composites: Tailormade to Suit Resources and Climate

According to Matthews and Rawlings (1999), composite's properties can be enhanced in a synergetic compound that ideally enhances performance around: Physical characteristics, mechanical characteristics, strength, toughness, temperature, mechanical properties, and improve fire and flame-retardant properties. Furthermore, two or more constituents of different properties can be synthesised to a component with another.

Here advanced material technologies reveal future opportunities in hindsight of traditional low-tech examples for exact positioning, forming, and shaping components in controlled environments that allow for prefabrication and controlled standards. An existing local material knowledge can be evolved into more refined applications with the help of advanced technologies such as 3-printing, nano-applications, and sensor positioning. On the other hand, the many materials proposed could also be combined in a low-tech effort. Such can add to developing communities to self-build their liveable habitats.

In resource-scarce biomes like arid drylands, even more delicate to be arranged beyond the characteristics listed above properties of eco-composites should extend considerations of material design to suit as well:

- Local resources
- Thermal properties: Thermal mass or insulation
- Overall Climate Design Principles
- Integrated passive cooling principles
- UV and Solar Impact in durability
- Activation of building components
- Material circularity (reuse or -cyclability, bio-degradability)
- Eco-footprint (GHG emissions, water, land)
- Life Cycle
- Socio-cultural context

Apart from the plentiful advantages and opportunities in developing composites derived from ecological matter, full recyclability might be comprised by bonding the matrix and filler materials, especially while utilising chemical transforming processes such as cementitious or heat transformation processes that might not be reversible. For that reason, we will elaborate in the next chapter on material combinations for eco-composites in the context of reuse of urban waste products, the production process, and end-of-life scenarios.

References

Matthews FL, Rawlings RD (1999) Composite Materials: Engineering and Science. Taylor & Francis

Stokke DD, Wu Q, Han, Stevens CV (2013) Introduction to wood and natural fiber composites. Hoboken, United Kingdom, John Wiley & Sons, Incorporated

Chapter 10
'eComposite' Tool for Ecological Composite Building Materials

Abstract For future ingenuity of bioclimatic building technology as well as working with renewable resources for future net-zero sustainable urban development, we propose a composition of compressive and tension strength materials applicable to compose composite materials. Furthermore, those material compositions are embedded into a circular urban repository approach where the consideration of reuse, recycling and upcycling plays a role as well. Low emission and sustainable production processes are also integrated into this combinatory matrix to ideate, design and development 'new' ecological composite materials for deserts and drylands.

Keywords Ecological Materials · Composites · Renewable Resources · Technology · Circularity

10.1 Circular Material Metabolism

When referring back to the intended relationship between materials, climate and design in Figs. 1.1 and 4.2 we miss in the previous mapping of potential 'ingredients' for new formations of eco-composites suitable for desert climates (Fig. 9.2) the discussion around sourcing, processing, and cycling, in short, the material 'metabolism' in conjunction to sustainable urbanisation in hot-dry regions.

When considering traditional materials as metabolic systems it becomes prevalent that building components such as adobe, sarooj and loam structures incorporate:

- A well-coordinated maintenance regime
- Additive material systems that can be repaired
- Material systems that can be renewed, recycled or biodegraded
- Resilience towards other usage purposes
- Renewable resources
- Resulting building shapes reflecting the intrinsic integrity of resources

This observation is not new but was employed by the German architect and theorist Gottfried Semper (1803–1879) in his concept of *Stoffwechsel* (metabolism, material transformation). His act of identifying an existing process of architecture and design conceptualization was a nod to a phenomenon that is well-known in the field: the

transfer of designs that were initially associated with the way one material was transformed to other materials (Moravánszky 2017).

Since our world and urban systems, in particular, have become not only in a materialistic sense complex, the search for clear concept how to enable *Stoffwechsel* with low entropy is the driving idea behind quantifying embodied energy, mapping LCA (Life Cycle Assessment) for environmental impact of, e.g. material systems. The ultimate goal is to keep materials in the 'loop' for renewed reuse or recycling of their constituents.

Hebel et al. (2014) demonstrate multiple possibilities for how to cycle waste as a resource back into potential building materials. They even go as far as to incorporate biological organisms as 'builders' into a biological 'factoring' of materials that they call 'cultivated building material' (listed as bio-utilised materials in Chap. 8.6). This opens up additional considerations that go beyond the pure sourcing of natural resources for ecological material systems. The utilisation of 'urban mines' as true local resources can be added into the pool for eco-composites. With the future goal of a circular building industry, the further proposed process loops (Figs. 10.1 and 10.2) can feed into the final product composition from various existing urban wastes and raw materials.

In the search for materials and building components that are compatible with the environmental prerequisites, a low-impact production and manufacturing process are fundamental and at the same time beneficial to the building components role. Thus, forming a tool for further investigations of how to feed ecological materials for drylands and deserts into an urban metabolism that is as close as possible is the next logical step.

10.2 Combinator for Eco-Composite Materials

Beyond the pure listing of possible reinforcement and binder materials, we propose a combination model in Fig. 10.1 to conceptualize possible material combinations in conjunction with the concept of circularity, the 'eComposite Combinator'. This model includes the combination possibilities of ecological materials from Fig. 9.2, adds existing urban wastes as resources, and makes sustainable production process recommendations in hindsight of the desired product form.

Overall, the extended model 'eComposite Combinator for Deserts and Drylands' (Fig. 10.2) comprises six axes designed to close the loop of material metabolism towards the desired circularity.

As introduced in 'Eco-Composite Ingredients for Deserts and Drylands' (Fig. 9.2) the first three axes map abiotic and biotic matrices and reinforcement materials that allow composing the different filler types from organic and inorganic decent with mineral or biotic binders. The (incomplete) material selection (in Chaps. 6 and 7) of this publication alone creates 107 material combination options to explore (just in the second or third material group hierarchies).

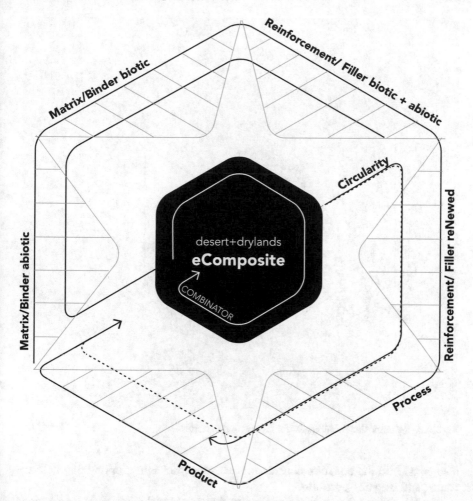

Fig. 10.1 Eco-composites combinator model

We add existing resources or so called 'urban waste' in the material metabolism on a fourth axis. Readily available concrctc, timber, plastics, and cellulose can be added into the mix of potential composites as 'renewed'[1] filler material.

After combining the 'ingredients', a fifth axis reminds of production processes accounting for the overall eco-footprint. The goal is to minimize power, water, land, waste (water) discharge, chemicals and, overall, the GHG. Sustainable Design considerations integrate 3R (reduce, reuse, recycle) rules for components. Later in the product stage and end of use cycle, integrated sustainable packing and logistics

[1] Used here as "upcycled" materials that maintain original properties to avoid a whole recycling process into raw matters that often (e.g. concrete) is not or hardly possible.

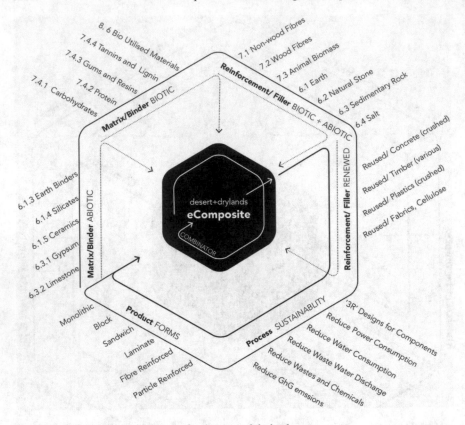

Fig. 10.2 'eComposite' combinator for deserts and drylands

also come into the equation considering reducing packaging, optimizing delivery routes, and shipping portfolio.

The last axis of the Eco-Composite Combinator Model (Fig. 10.2) lists options for desired forms of the composite material suited to building in drylands. According to Priyanka et al. (2017), a common classification of composites is Reinforcement Types (Structural Sandwich or Laminate; Fibre-Reinforced; Particle-Reinforced), and Matrix Types such as ceramic or polymeric referred her for the building industry as blocks and monolith product form of the eco-composite. From here, the material is implemented into the construction process. Later at the dissemination stage, it can be added to renewed fillers for other eco-composites and almost closes the circular material metabolism.

10.3 Examples for Potential Desert and Drylands Eco-Composites

To take material formulations into development, these phases are usually involved: material design, component development, modelling, prototypes, human health and life cycle assessment, dissemination and exploitation. Beyond the established hybrid composite materials in Chap. 8, we would like to provide in the following some examples of concurrent sustainable material developments described in the literature and through our current ongoing research projects.

One big topic that applies to all sustainable construction globally is the development of alternatives to Portland Cement and Reinforcement Steel.

Peters and Drewes (2019) describe, for instance, how the Berlin-based Federal Institute for Materials Research and Testing (BAM) has developed a bio-based and waste-based (refer to options in Sects. 7.1–7.3) concrete with a significantly lower cement clinker content. The team used the highly adhesive starch (Sect. 7.4.1) of the cassava root's skin as an additive. The ash from the root's burnt skins contains a high proportion of reactive silicon dioxide and can be used as a sustainable cement substitute (Sect. 6.3.2 Geopolymer). Coconut fibre (Sect. 7.2), acacia gum (Sect. 7.4.3), rice husks (Sect. 7.1), and sugar cane ash are among the other ingredients in the concrete formulation.

They describe another example of concrete that uses vegetable fibres (Sect. 7.1) to replace the cement's adhesive function, reducing the cement content significantly compared to traditional concrete. Additional waterproofing, fire protection agents, or fungicides are not required because of the unique concrete formulation. Steel reinforcement is no longer necessary due to the additional reinforcement provided by the vegetable fibres (e.g. Loam Hemp Panel (8.5.1) composed in Fig. 5.4).

Biomass added to concrete mixes could improve its thermal insulation properties when used with foamed glass (Sect. 6.3.2) as an aggregate (e.g. Fig. 10.5 Spinifex-Foam Glass Structural Insulation Panel SIP composite).

In our concurrent research, we are testing the tensile strength improvement in geopolymer concrete (6.3.2) through replacing steel mats with abundant agricultural waste fibres of Abaca Hemp (see Fig. 10.3 'BananaCrete').

The same fibres although in random strains are additionally tested for bio-plastic laminates in a mix with biotic binders (in this case Polylactic Acid PLA from Sect. 7.4.1 starch). Figure 10.4 'BananaPlastic' shows a first experiment sample.

According to Knippers et al. (2012), the research into cellulose-based functional fibres is anticipated to produce great results. The natural polymer cellulose (7.1 non-wood fibres) can be dissolved and spun into continuous fibres without changing its chemistry. This means that bespoke fibres with reproducible properties can be created. The fibres can be made magnetic, thermoregulating, or electrically conductive.

Interesting for activated cooling integration of building components in hot environments could be textile heating or cooling systems or climate-control membranes incorporated into a textile façade.

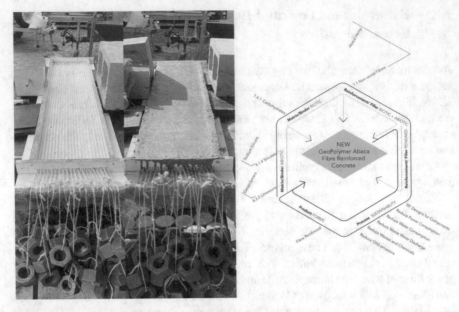

Fig. 10.3 'BananaCrete' geopolymer reinforced with non-wood fibres monolithic cast product

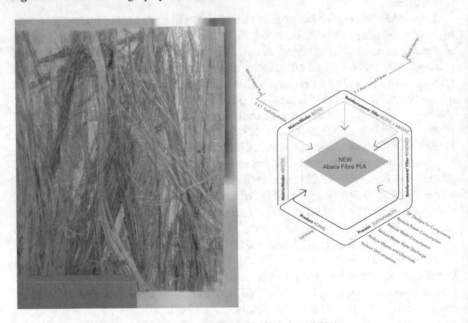

Fig. 10.4 Composite development: BananaPlastic fibre-reinforced PLA

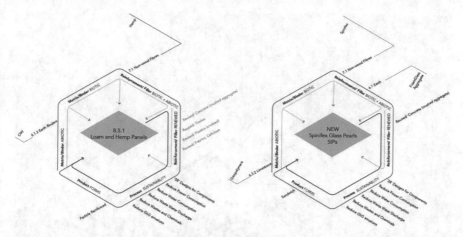

Fig. 10.5 'eComposite' combinator applications: loam hemp panel (8.5.1) and spinifex-foam glass SIP (new)

The extended combinator model presented in Fig. 10.6 'eComposite Combinator for Deserts and Drylands' allows for millions (10^{11}) of combination possibilities between biotic and abiotic matrices and reinforcement phases in combination to existent urban waste products and sustainable processing phases to explore ecological materials further and tailor-make them for climate-adaptive buildings in desert and drylands.

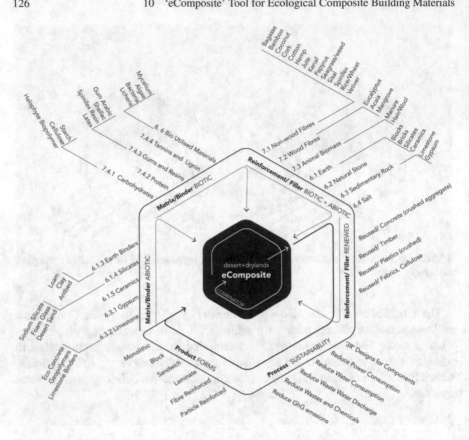

Fig. 10.6 'eComposite' combinator for deserts and drylands-extended version

References

Hebel DE, Wisniewska MH, Heisel F (2014) Building from waste: recovered materials in architecture and construction. Birkhäuser, Basel

Knippers J, Cremers J, Gabler M, Lienhard J (2012) Construction manual for polymers+ membranes: materials, semi-finished products, form finding, design. Birkhäuser, Basel

Moravánszky Á (2017) Metamorphism: material change in architecture. Walter de Gruyter GmbH, Basel/Berlin/Boston, Switzerland

Peters S, Drewes D (2019) Materials in progress: innovations for designers and architects. Birkhäuser, Basel

Priyanka P, Dixit A, Mali H (2017) High-strength hybrid textile composites with carbon, kevlar, and E-glass fibers for impact-resistant structures a review. Mech Compos Mater 53(5):685–704

Chapter 11
Conclusion: Future Desert Architecture Material Systems

Abstract We discuss the applicability and the future challenges for bioclimatic building endeavours posed to ever-increasing construction activities at the rate of swindling renewable resources. The choice for low-emission building materials and systems is considered within the holistic smart design of building techniques. Based on ecological ingredients for material compositions in the previous chapters, we aim to expedite integrative research topics. We conclude that future ecological material systems consider integrated multifunctional building components and serve the bioclimatic design considerations for net-zero desert architecture.

Keywords Innovation · Desert Architecture · Renewable Resources · Climate design · Smart Facades

We have attempted to provide an overview of ecological material and the challenges of building in the desert and drylands. Extreme heat and aridity add to the challenge for designing buildings for comfort and sustainability within rapid urbanisation in increasing desertified areas. Concepts of Bio-based materials, Biodegradable materials, Recycled materials, Lightweight materials, Thermal Mass and Insulation incorporation, are discussed in the collection of the abiotic, biotic, and hybrid materials of the previous chapters.

The resulting Eco-Composite Combinator for Deserts and Drylands (in Chap. 10) is a mere start to explore many more options for climate-friendly materials. It aims to trigger designers, architects, students, material scientists, engineers and builders for future research and development. As indicated in Fig. 1.1, the choice for low-emission building materials and systems needs to be considered within the holistic smart design of building techniques to comprise a true synergetic solution to net-zero buildings and cities targets.

D. A. Ottmann, *Ecological Building Materials for Deserts and Drylands*,
SpringerBriefs in Geography, https://doi.org/10.1007/978-3-030-95456-7_11

11.1 Future of Material Systems as Integrated Building Components

Specifically, for different climate zones, we recommend that further conceptualisations be made to better connect the materiality as fractals to overall liveable and comfortable building assemblages.

Materials systems and building envelopes must become more integrated with a multitude of aspects of form, process and structure as 'third' skin (refer to Sect. 3.3), through:

- Multifunctional Smartness:

 Particular emphasis can be placed on the 'smartness' of climatic compensation (such as phase change materials), multifunctionality, energy converting material systems, light-conducting, and aspects of active climate system (ventilation, cooling, light, air purification, humidity and temperature regulation) functions.
- Sensor Node Skins:

 Many cities have transformed into data collection nodes that are smart and intelligent. Temperature, humidity, noise levels, signals, cars, and people are all measured. The artificial intelligence AI industry will continue to grow. As a result, building materials at the interface to measurable environmental data could increasingly become a multifunctional layer of sensing, measuring, and potentially synchronously adapting to the desired state of surface temperature, humidity, and so on.
- Energy Convertors:

 Façade systems could support converting sunlight, wind, vibrations, temperature differences, biochemical processes. As energy 'harvesters' they represent nodes for interconnected smart desert cities. Convertor Envelopes for renewable energy harvesting could incorporate: Mini solar cells, liquid lenses (Concentrated Photo Voltaic, Concentrated Solar Power), Biochemical Energy conversion, Algae (for oil production), Kinetic energy converter, Piezo-electric energy systems, Microturbines (wind tower slots as Bernoulli system), small scale hydroelectric power generators and activated parts as water cycling and colling systems.
- Bio-facturing:

 The materiality and shape could also host living organisms such as plants, bacteria, fungi to further 'grow' or protect the 'skin'. Such organisms could add as 'bio-builders' to converting waste materials into recycled ingredients (e.g. cellulose) for additional metabolic cycles and material development (e.g. into desert biopolymers).
- Nutrients Productivity:

By integrating (micro) farming vertically into cladding or skin systems, ecological materials and the layering thereof could enable the growing of various food sources within. A living façade that goes beyond the pure notion of 'green' and provides nutrients in building integrated vertical agriculture.

11.2 Material and Design Synergies

In architecture, materiality exceeds the pure additive notion of material extraction and production into a product. It can form synergies between the Vitruvian imperatives of *venustas, firmitas & utilitas* and additionally inform the ever more pressing environmental parameters around *humanitas* (humanity) and the *oikos* (household, environment).

The architectural designer explores the laws of the materials. The inner forces of carrying and holding, the principles of joining and, ultimately, the work that goes into things emerge. Construction principles, component sizes, and the material's nature all help reinforce the design's internal logic. Things emerge, gradually assuming the appropriate position within the structure and the 'correct' shape and infusing meaning into the material. The visual expression, the olfactory experience, the tactile sensation, and the acoustics all take on a tangible quality.

The transfer of vernacular architecture into contemporary design approaches (like Frei Otto's reinterpretation of the Arabic *Bait* (animal hair fabric tent, house) as relationship between form, force, and mass for Towaiq Palace in Riyadh, KSA) is based on a deep understanding of the environmental phenomena that drive form toward optimisation, rather than on form imitation. Tents and yurts are also optimised structures, utilising traditional materials such as fabric or foldable timber lattices to create light and strong structures suited to the climate.

The here attempted overview of ingredients to investigate new combinations (10^{11} just in this incomplete selection) for ecological materials is ready to be further discovered. Furthermore, appropriate desert design strategies combining passive methods of the vernacular and an integrated high-tech approach of the twenty first Century will need to be explored in synergy to achieve net-zero buildings and cities as co-existing systems within the socio-cultural and bioclimatic environment.

We wish all readers an exciting journey to experiment with future ecological materials. New combinations of the here listed natural resources for a future that meets net-zero targets contribute to low-impact climate design decisions and promote the health of the planet and its people.

Index

Printed in the United States
by Baker & Taylor Publisher Services